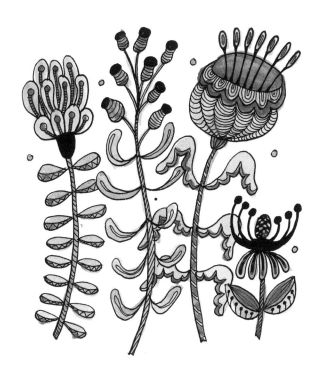

FLORABUNDA STYLE

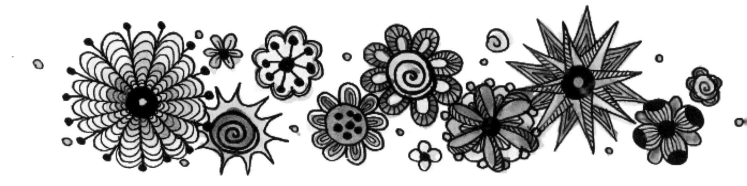

All the flowers of tomorrow are in the seeds of today.

ISBN 978-1-57421-991-3

Printed in China
Second printing

FLORABUNDA STYLE

Super Simple Art Doodles to Color, Craft & Draw

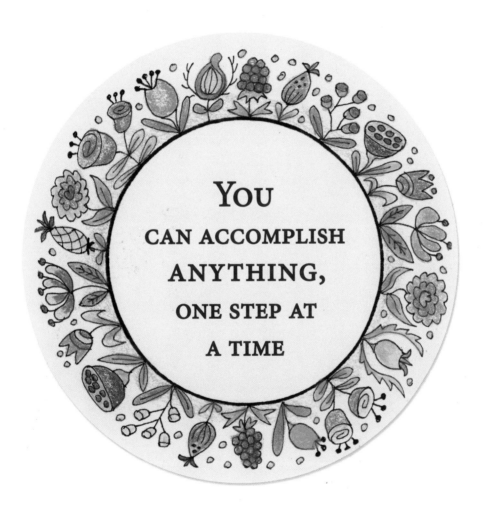

You CAN ACCOMPLISH ANYTHING, ONE STEP AT A TIME

Suzanne McNeill

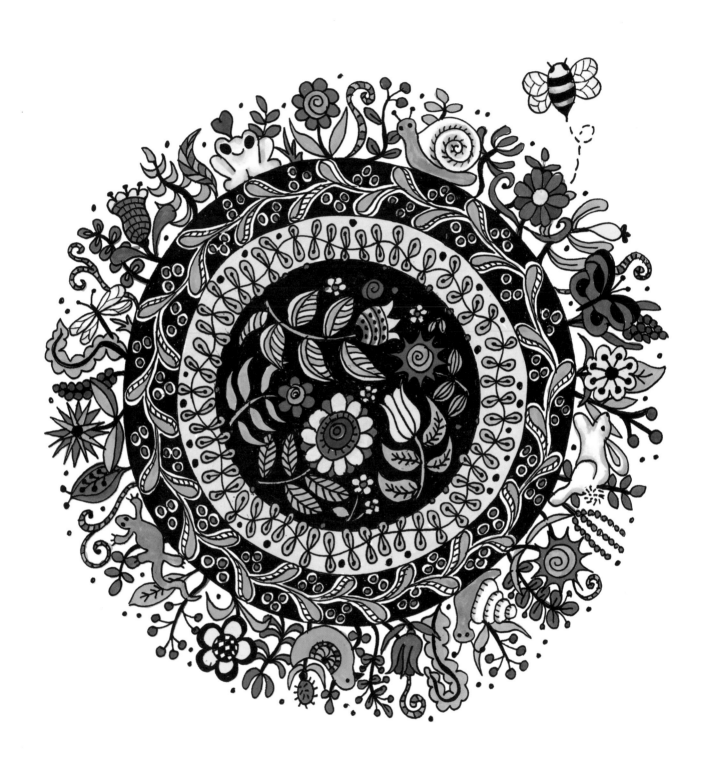

Contents

*Use the practice pages
in each chapter to try
drawing designs!*

What Is FloraBunda?

Picture yourself walking in a garden. Can you smell the flowers? Hear the dew dripping from the leaves? You feel relaxed, peaceful, and immersed in joy.

Now you can recreate that happiness every time you pick up a pen. FloraBunda is a new collection of simple, easy-to-draw, nature-inspired art doodles that you can use to create your own unique art. Whether you already love drawing or have never thought of yourself as someone who can draw, you'll find the simple shapes of the flowers, leaves, and vines of FloraBunda easy to learn. Relax your mind and let your creativity flow as you sketch, mixing and matching more than 200 elements in this book to create unique compositions. Then use markers, colored pencils, watercolors, or any favorite medium to magically transform your inky doodles into exotic, lively plants.

Drawing simple patterns and letting a garden grow from your hand will rejuvenate your soul and invigorate your creativity. Go ahead, draw a garden, add some pods, toss in some leaves, twine a few vines. Experiment and have some fun. Be eclectic, be whimsical. Enjoy yourself. In no time you'll be creating gorgeous art, and every piece you draw will be uniquely yours. It's time to abundantly bless your creativity with FloraBunda.

floribundus *(Latin):* flowering freely

Use the elements of FloraBunda to create simple, meaningful messages with a black pen.

Fill a shape with densely packed designs, from big to small.

FloraBunda design elements can be mixed and matched to create unique compositions and shapes, and colored to achieve a tangible feel.

How to Use This Book

First of all, this book is made for drawing in! Each section of designs opens with a preview of all the designs you can learn to draw, plus a sample step-by-step design to show you how easy it is to draw any of the designs. On the drawing pages that follow, there's plenty of empty space for you to practice your favorite elements right next to a sample. You'll also find full- and half-page designs in black and white that are just waiting to be colored. And it's all on high-quality artist paper, so most pens and markers won't bleed through!

At the front of the book, see how different drawing tools like pens, markers, and watercolors can be used to add depth and interest to your art. Want to work with brush markers? Gelli pens? Basic black pens? Info and inspiration for each of these and more is included!

Mixed in with the designs, you'll find fun tips and beautiful art to keep you thinking and give you new ideas for your drawings. Try your hand at a petal mandala, experiment with framing designs, and more.

This book also features fun, easy projects that require little to no special technical skills and show you ways to incorporate FloraBunda designs into crafts and gifts like boxes, bracelets, and dishware. FloraBunda isn't limited to two dimensions!

Draw Inside!

Whenever you see airy pages with lots of white space with inspiring art and sample design elements mixed in, that's your space to practice designs and sketch illustrations.

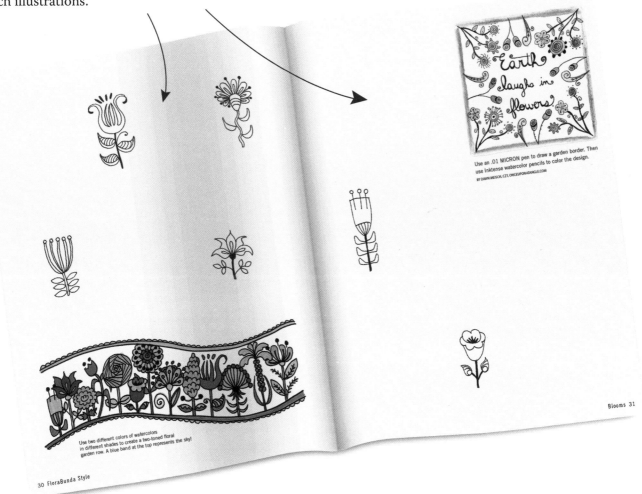

Use an .01 MICRON pen to draw a garden border. Then use Inktense watercolor pencils to color the design.
BY DAWN MEISCH, CZT, ONCEUPONATANGLE.COM

Use two different colors of watercolors in different shades to create a two-toned floral garden row. A blue band at the top represents the sky!

30 FloraBunda Style

Blooms 31

Tangled Apron

Zentangle® has been a part of my life for many years. Zentangle is a relaxing, meditative drawing method that turns simple patterns, or "tangles," into artistic design. The Zentangle art form and method was founded by Rick Roberts and Maria Thomas. But even back in 2011, when the photo below was taken, I was experimenting with floral doodles and drawings, incorporating them into my Zentangle art and creating new designs and tangles. I was inspired to draw flowers, birds, and tangles on this store-bought canvas apron. Like Zentangle, FloraBunda art can be done anywhere and doesn't require artistic talent. It just requires that you let go and enjoy the process! To learn more about Zentangle, check out the book *Joy of Zentangle* and visit *www.zentangle.com*. (Zentangle is a registered trademark of Zentangle, Inc.)

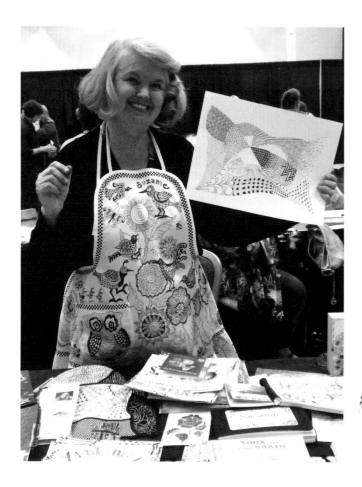

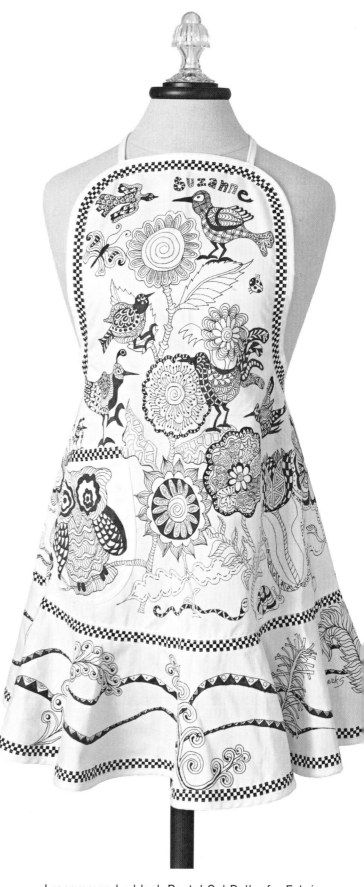

I recommend a black Pentel Gel Roller for Fabric to draw on canvas or fabrics.

The Beauty of Botanicals

Nature and botanicals have always interested me. At Southern Methodist University, my degrees were in Art and Biology. One of the most interesting experiences I had was in a botany class. Each student had to chose one acre of undeveloped land. The assignment was to identify every plant on that single acre. That experience was the genesis of my botanical art.

Last fall, I collected amazingly interesting dried flowers and leaves from nature. I positioned each one on watercolor paper (140# HP). As I lifted up each flower, one at a time, I used a black Pigma MICRON .05 pen to draw it in place. Then I added watercolors and a shadow with a brush. The result, which you see here, is a realistic rendering that almost pops off the page and can give you a taste of real florals even when you're far from nature.

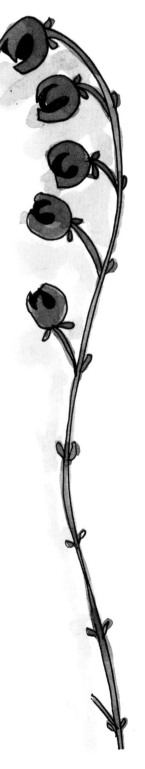

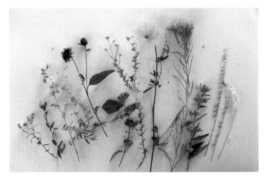

I positioned a grouping of flowers on watercolor paper.

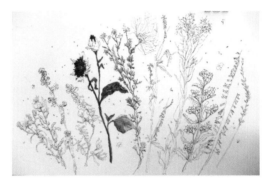

I outlined each flower with a black .05 MICRON pen.

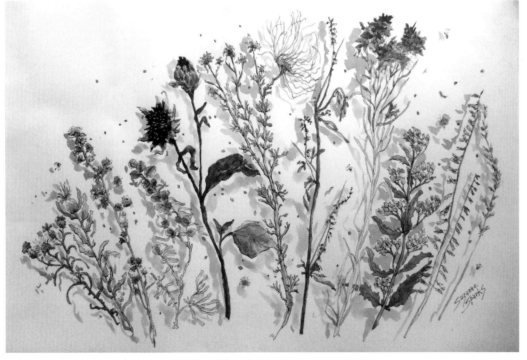

I added dimension with watercolors and a shadow.

Getting Started

In this section, you'll learn how to get started drawing designs, making compositions, and adding color. In no time you'll be ready to start drawing!

How to Draw Design Elements

Following are just a few examples of how the already simple design elements in this book—each individual flower, vine, leaf, and the like—can be broken down into even simpler strokes and shapes and built up to create the final element.

TIP Most pens and markers won't bleed through the paper used in this book. A few will, however, so test your tool on a corner of a page to see whether it will work!

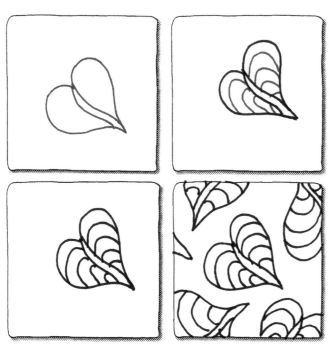

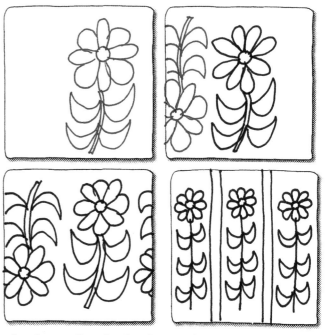

This heart leaf starts with a simple heart shape and, just by adding lines, becomes a leaf. Then add color or change up the lines within the leaf for variation.

Create a pattern by drawing an element once, then repeating it in a variety of different ways, such as flipped or in a row. Background colors can make designs really pop.

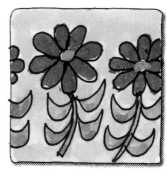

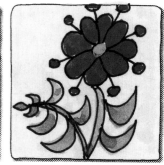

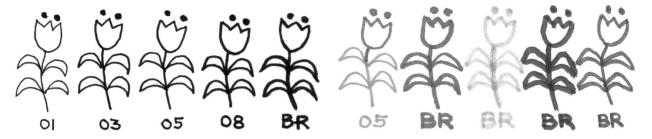

Pens of different thicknesses will result in subtly different-looking designs. Choose the pen thickness depending on how much space you want to fill and how detailed you want to be. See page 14 for more info on pens.

You can use colored pens (the first flower) and brush markers (the rest of the flowers) to draw the design elements in color from the very start.

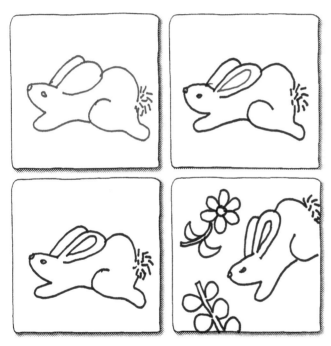

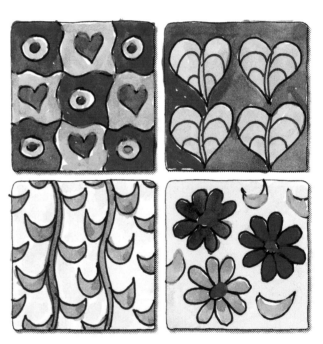

Simple shapes become recognizable animals—no need to study the creature's real anatomy! One fun option is to put an animal element on a background using other design elements such as flowers.

You'll learn more about adding color in the following pages.

TIP For more help with drawing, see the first page of every different design element chapter for a quick step-by-step example!

Adding Color

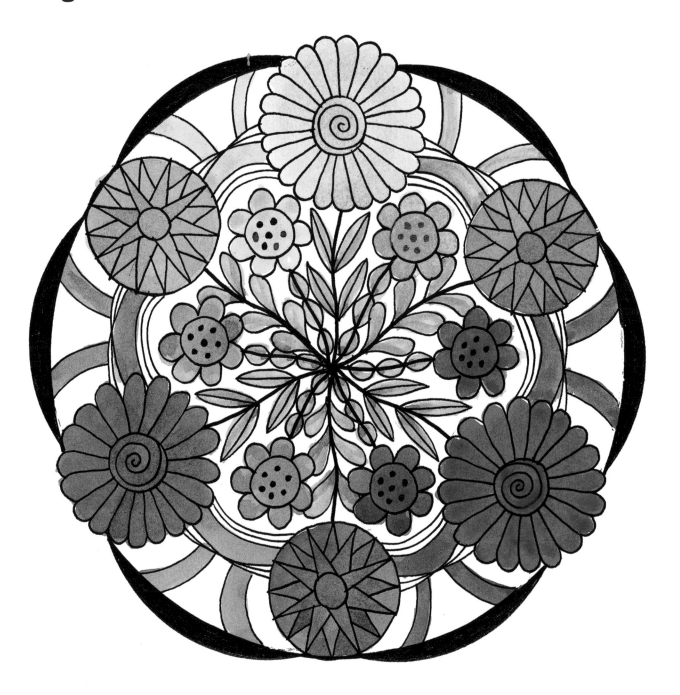

This color wheel, done in pen and watercolors, shows a taste of the spectrum available to you when coloring your designs. The primary colors—yellow, red, and blue—are the building blocks of all color and can't be created by mixing other colors. Secondary colors—orange, purple, and green—are created by mixing the primary colors. And tertiary colors result when you mix a primary color and a secondary color.: blue-green, yellow-green, yellow-orange, red-orange, red-purple, and blue-purple. And don't forget grays and browns, which result from lots of mixing of different colors.

Remember, this is just a sampler—you can get many more shades out of the color wheel than shown here! Have fun mixing colors yourself or shopping for the perfect premade shade for your piece.

Complementary Colors

These colors appear opposite one another on the color wheel and combine to produce black.

Analogous Colors

These colors appear next to one another on the color wheel.

Monochromatic Colors

These colors are all variations of one single basic color, or hue.

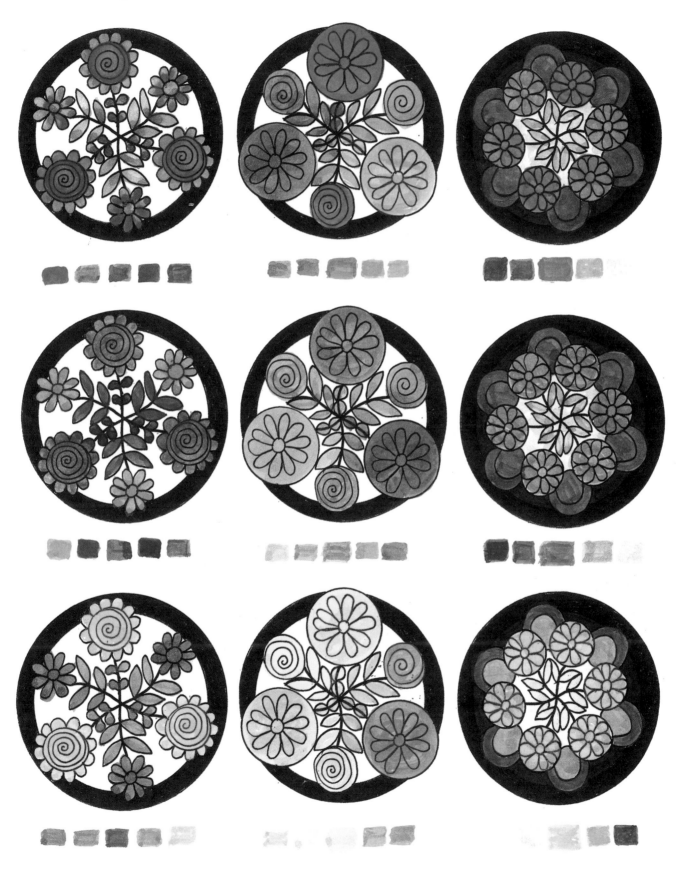

Tools

In this section you'll learn about many different tools and techniques you can use with your FloraBunda art. From pens to paints to embellishments, there are lots of choices!

Pens

Pens and markers are available in a variety of tips for different purposes. The .005 tip is the thinnest line for adding very delicate details. An .02 is good for drawing details, an .05 for drawing outlines, and an .08 for filling in black areas. Experiment with all the sizes to find what works best for you and what each different design requires. Brush markers take it to the next level, adding thickness and texture to lines (see more on brush markers on pages 16–17).

1. Draw the basic daisy shape.
2. Add black detail to the petals.
3. Using a fine-point pen, add additional details to the petals and center.

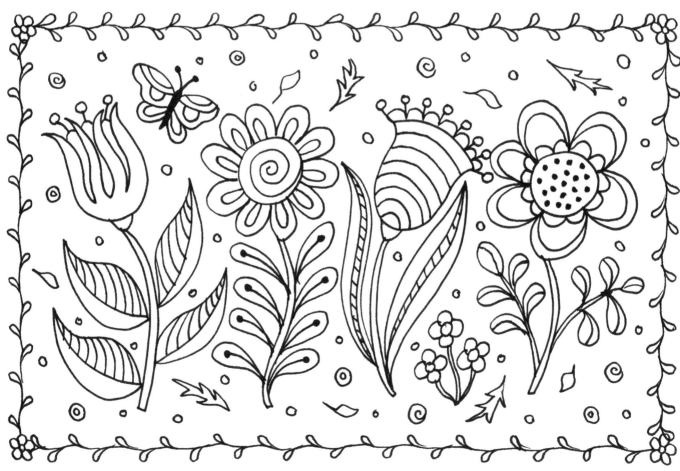

This piece was drawn entirely with an .05 pen and is moderately detailed.

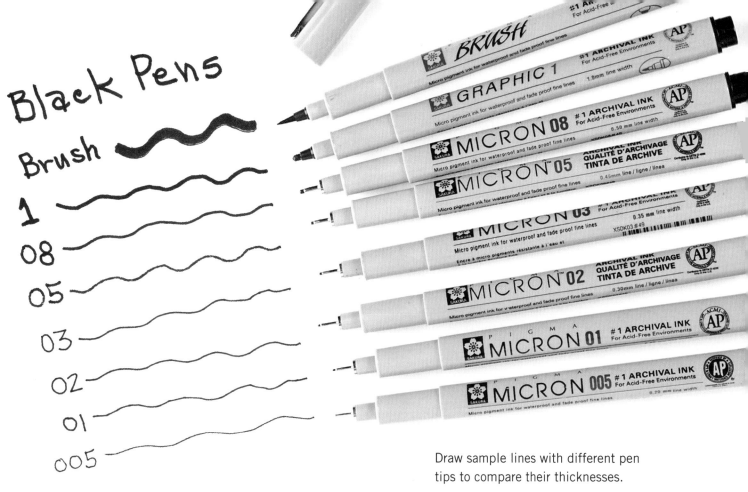

Black Pens

Brush

1

08

05

03

02

01

005

Draw sample lines with different pen tips to compare their thicknesses.

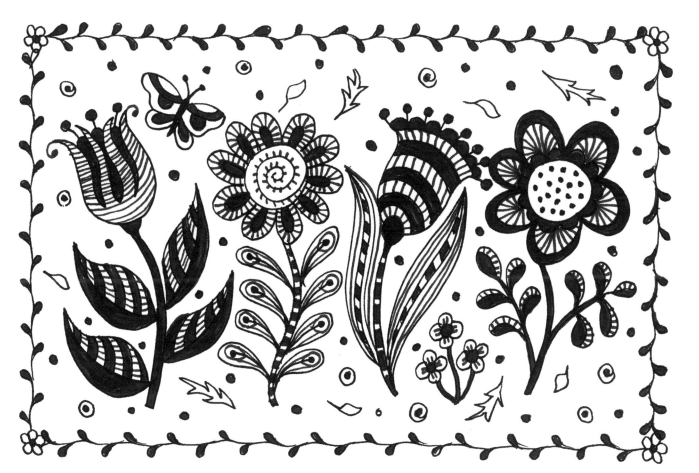

By adding additional details and coloring in areas with black (in this case, with an .08 pen), the same design transforms into a drastically different piece.

Colored Pens

If you prefer the fine, solid lines of pens, you're not limited to basic black! Try using colored pens in similar thicknesses as the black pens. You'll be delighted at the surprising diversity of the results.

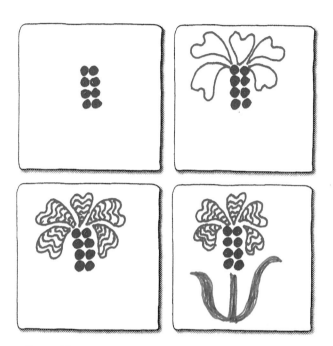

Fancy Flower

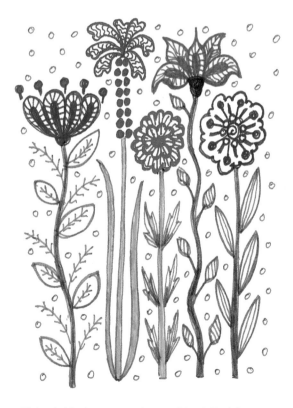

This vivid piece was done with .4 Stabilo pens.

Brush Markers

Brush markers have versatile tips that you can use to vary the line thickness as you are drawing and coloring. Many brush markers also have a fine pen tip on the other end of the tool that you can use to draw or fill in small details in the perfectly matching color.

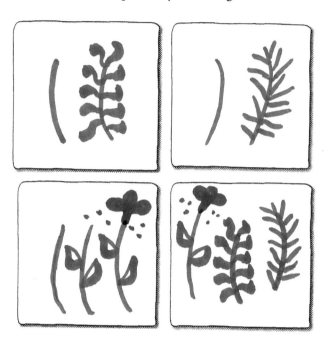

Twigs, Stems, and Blooms

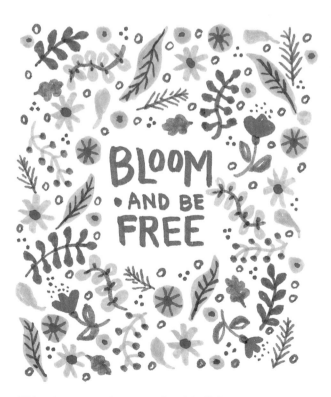

This piece was done purely with Koi brush markers, with no outlining of the shapes in pen, which gives it an open, soft feel.

COLOR
Colored Pens
Stabilo
Micron
Pitt
Prismacolor
Tombow

Brush Markers
Pitt
Koi
Tombow

Colored Pencils + Watercolor

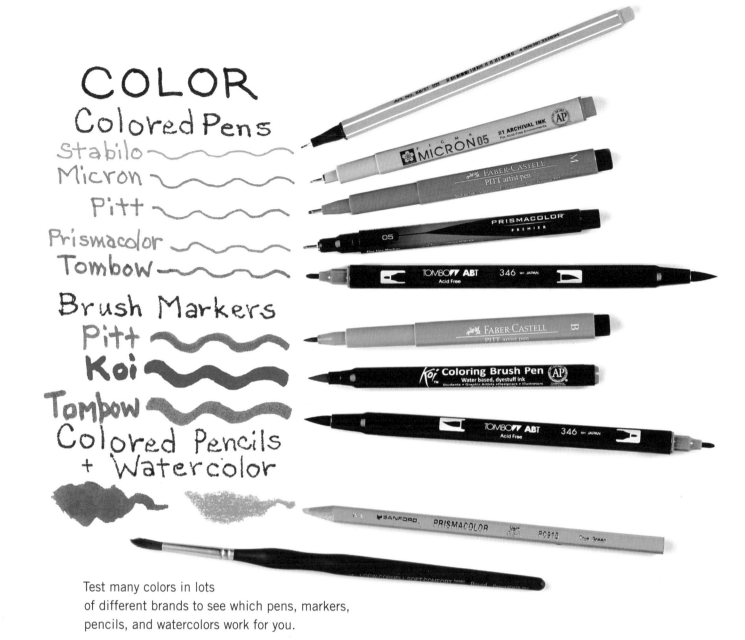

Test many colors in lots
of different brands to see which pens, markers,
pencils, and watercolors work for you.

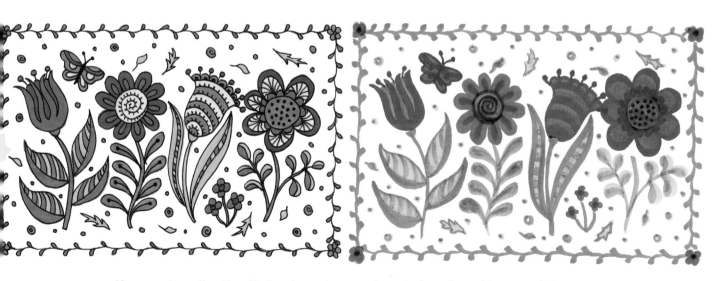

You can draw directly with brush markers, or draw designs first with pen and then
color them in. The two effects are very different! The first piece was colored with Pitt
markers, and the second piece with Koi markers.

Watercolors

Watercolors can be used in a variety of ways. See the different options in the mini step-by-step pairs below. You may need a little practice mixing colors and moving your brush to get the effects you want, but it won't take long until you're creating beautiful pieces of watercolor art with FloraBunda designs.

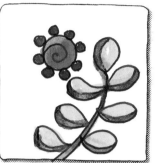 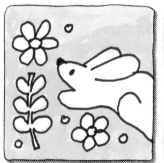

Colored Design

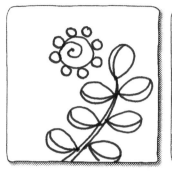 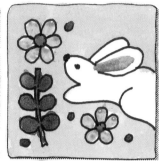

Colored Design and Background

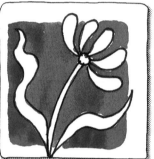

Colored Background Patch

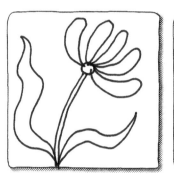

Watercolor Design

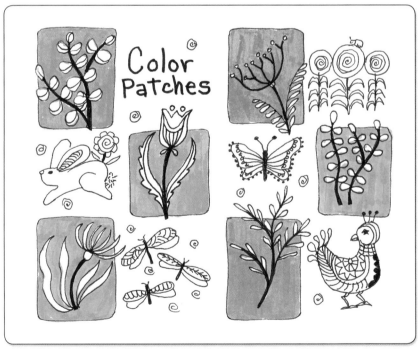

Watercolors can actually create some different textures, as you can see here.

Alternating color patches make a pretty quilt-like effect here.

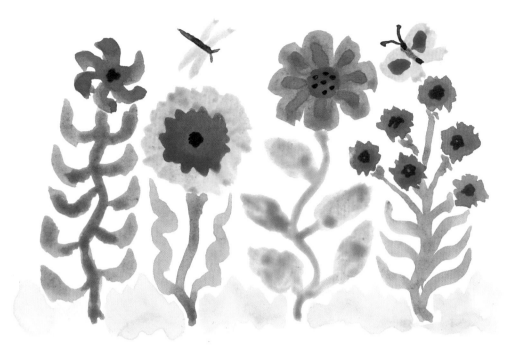

This piece was painted purely with watercolors.
It has a bit of an otherworldy feel.

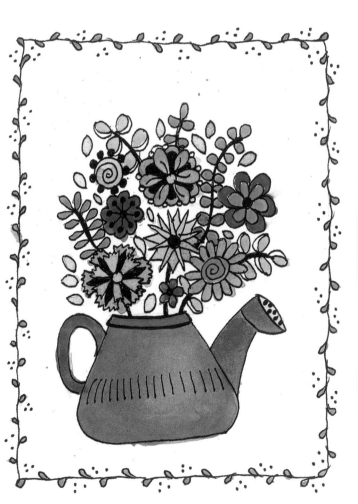

This pretty card illustration mixes watercolor
and fine-tip pen lines.

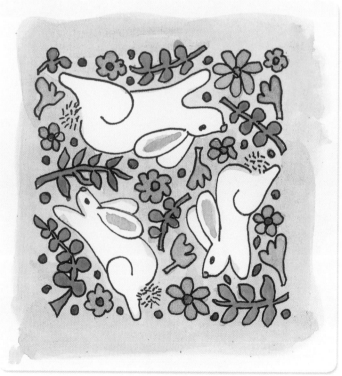

Don't be afraid to let the watercolors slip outside the lines—
it makes the whole effect of a piece of art less rigid.

Paint Splats

Sometimes it's fun to start with the color instead of the design! Use watercolor to make one or more roughly circular splats of color. Don't be afraid to let the edge be textured. Then draw a fitting design on top of the splat.

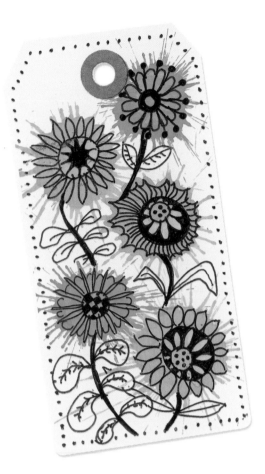

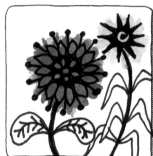

Paint Splat Flowers

This creative gift tag was done with very splashy paint splats and an .05 MICRON pen.

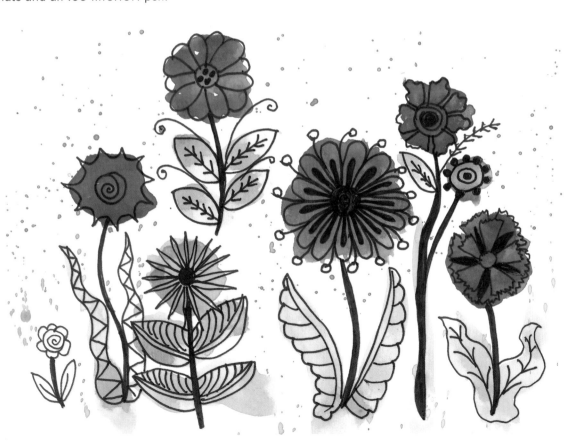

Incorporate some paint splatter with your paint splats! As shown here, you can also make splats for leaf shapes and other shapes, not just the flowers themselves.

Colored Pencils

For sometimes soft, sometimes vivid, highly smudgeable, and usually erasable color effects, turn to colored pencils.

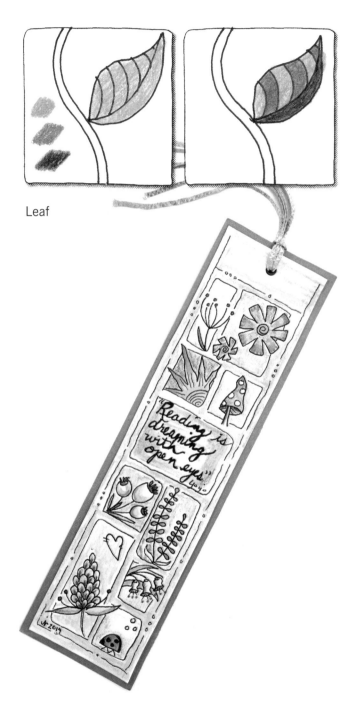

Leaf

This segmented bookmark uses soft pastel colors coordinated with flowering designs to create a lovely effect. To make it, cut a piece of cardstock to 2" x 8" (5 x 20cm). Use a pencil to divide the area into sections. Write a sentiment in one of the sections and add designs and color. Glue the piece to a slightly larger piece of lavender cardstock.

BY JANET NORDFORS, CZT, JANETNORDFORS.COM

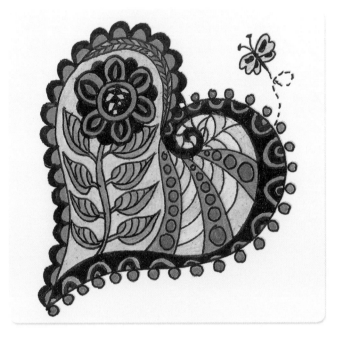

You barely notice the black .05 MICRON pen outlining in the vividness of these colors.

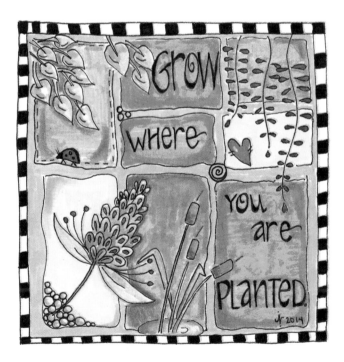

You can divide a shape into geometric sections for an organized but still natural effect. First divide the area into sections with a pencil, then write your sentiment with only one or a few words in each section. Then add designs, and color with colored pencils.

BY JANET NORDFORS, CZT, JANETNORDFORS.COM

Gel Pens

Break away from the norm by creating and coloring designs on black backgrounds. With gel pens it's easy!

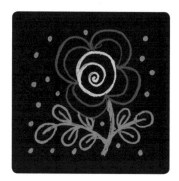

1. Draw a spiral shape to make the center of the flower.
2. Add moon-shaped petals around the center.
3. Add leaf shapes and dots to finish the flower.

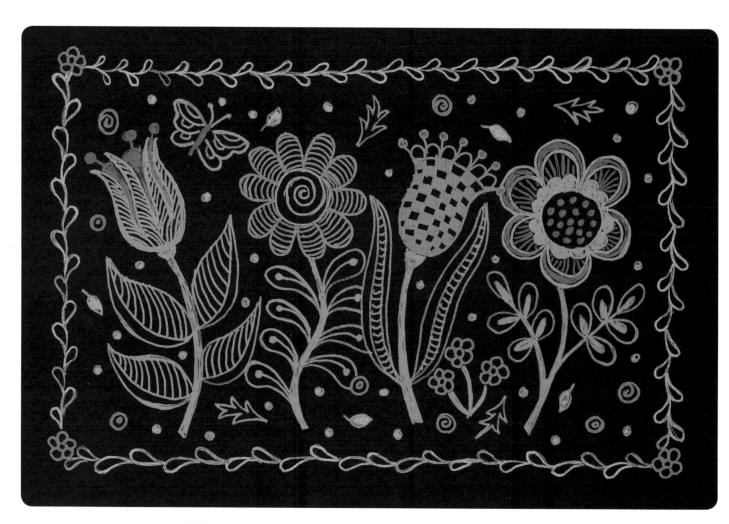

This piece was done with Gelly Roll Moonlight pens by Sakura.

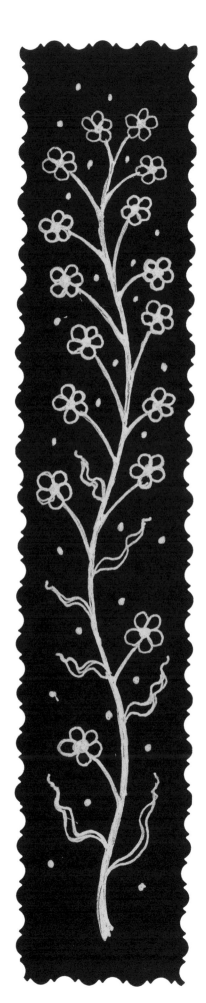

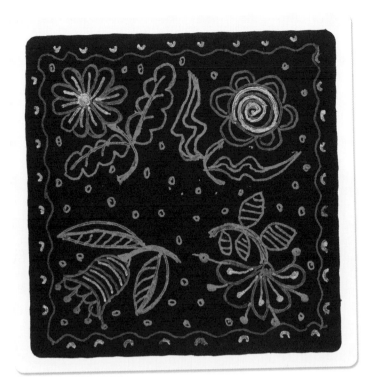

Just a few colors together make a nice effect.

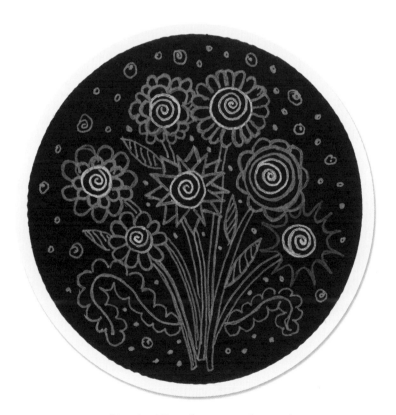

Circular tiles of paper make great
canvases for gel pen art.

Look how bright gel pens appear on black! You can almost
get a neon sign effect right there on your paper.

Embellishment Flowers

With these little flowers and a bit of basic glue, you can create 3D FloraBunda art. Just lay down one petal layer at a time as shown in the step-by-step to the right, add a central gem if desired, and have fun embellishing around the blooms.

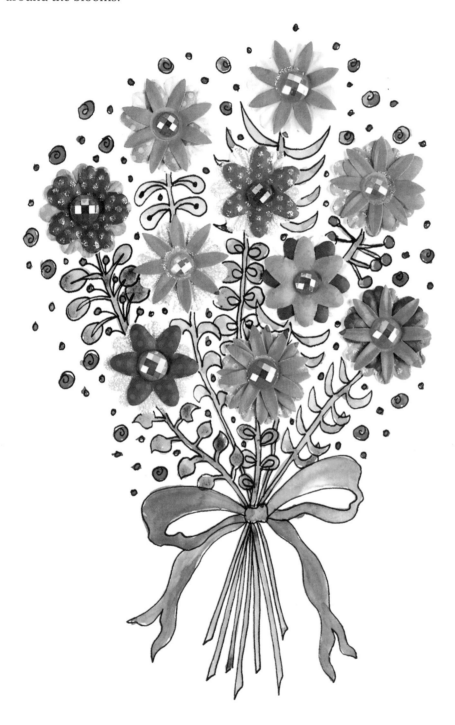

Create a whole bouquet of beautiful flowers using this technique. This piece was drawn with an .05 MICRON pen and colored with watercolors.

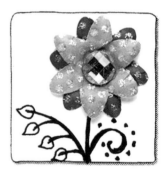

Embellishment Flower

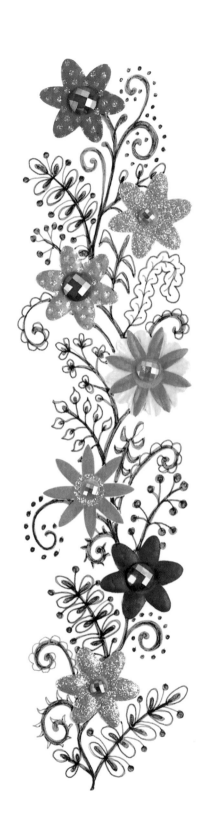

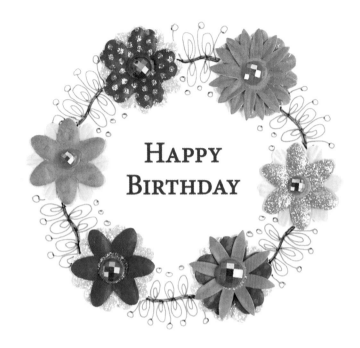

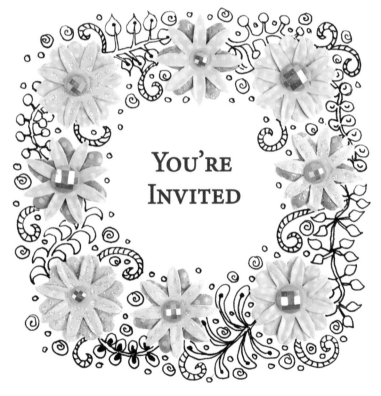

Embellishment flowers make great borders for cards and invitations. Print or handwrite your personal message inside the shape. Or just use the design like the one shown at left along the edge of a page.

The Designs

Now that you've been introduced to the basic idea of FloraBunda and all of the fabulous art materials that you can use, let's start the fun! In this part of the book, you will find nine different design collections. Each collection includes inspiring pieces of finished art, step-by-step drawing, pages to color, and—best of all—room for you to practice drawing right inside the book! Enjoy this space, because it's all yours.

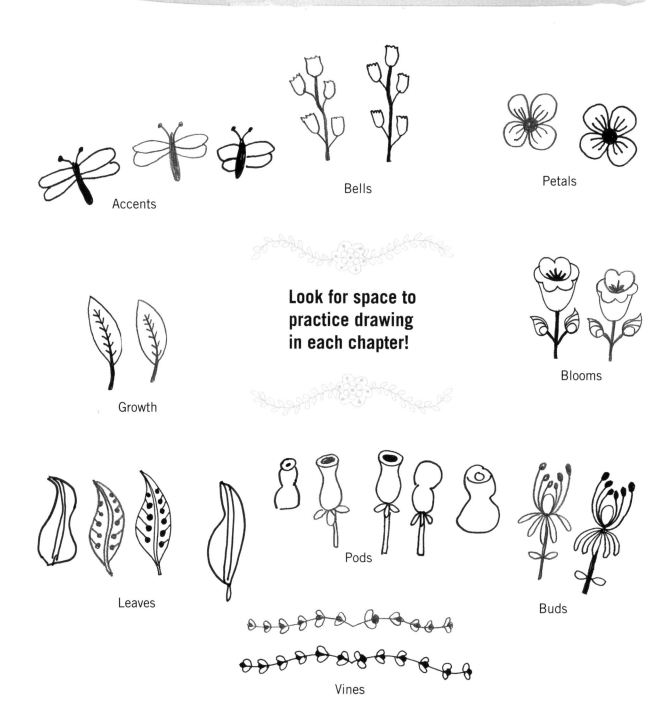

Accents

Bells

Petals

Look for space to practice drawing in each chapter!

Growth

Blooms

Leaves

Pods

Buds

Vines

Make Your Garden Grow!

Create an overflowing garden by layering your
FloraBunda designs! Go ahead—finish each of the vines
below by following the example or planting your own
flower ideas!

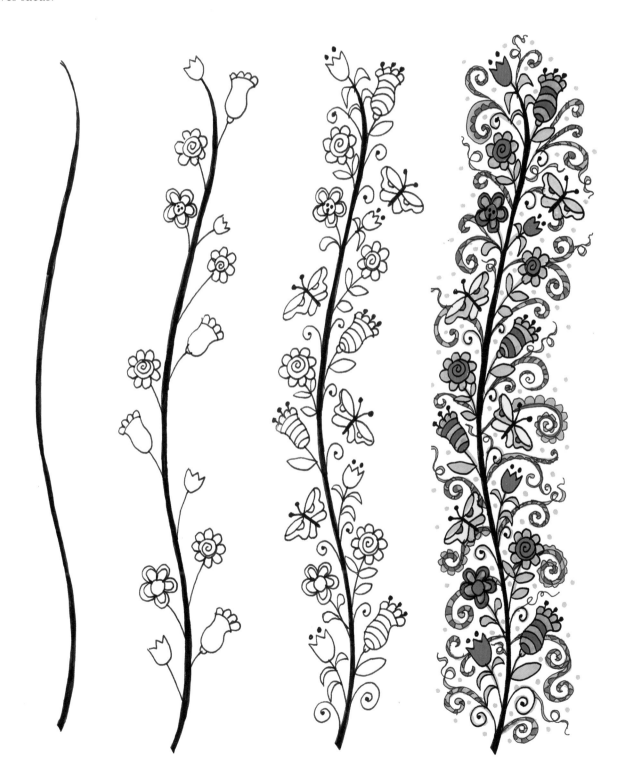

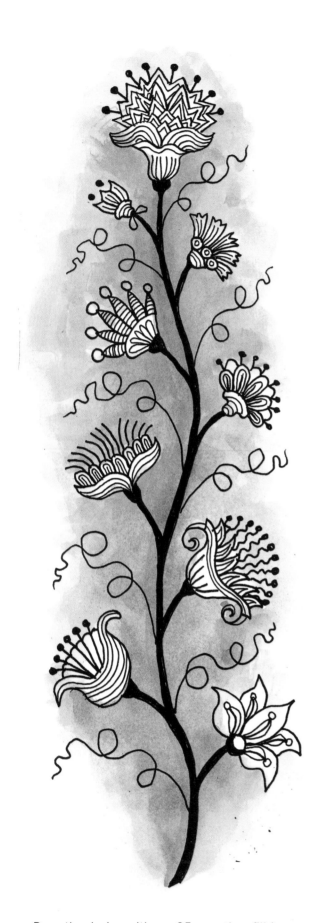

Blooms

It's fun to mix and match patterns to create your own one-of-a-kind flower creations.

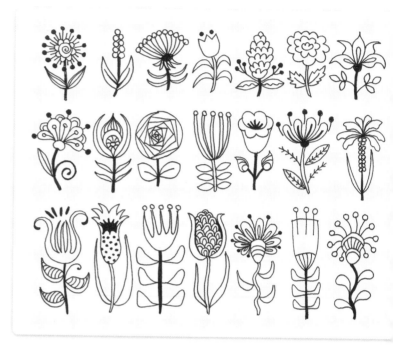

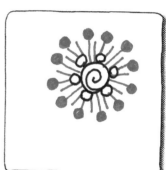

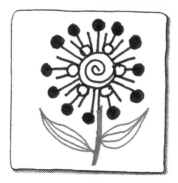

1. Draw a spiral with circles around its edges.
2. Add petal details with lines and filled-in circles.
3. Add a stem and leaves.

Draw the design with an .05 pen, then fill in areas with an .08 pen. Color the background with watercolors.

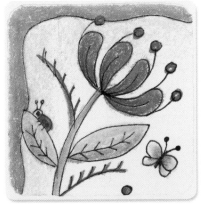

Embrace Life and BLOOM

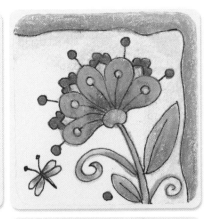

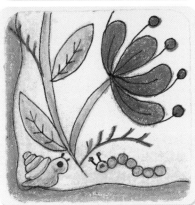

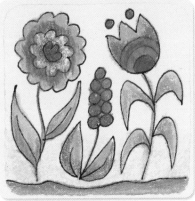

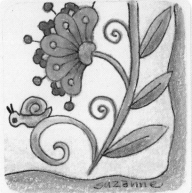

Write a sentiment on one 2" (5cm) paper tile using a Pigma MICRON pen. Draw
designs on five other 2" (5cm) tiles, creating a border and connecting all six tiles.
Color the design and assemble all the tiles together.

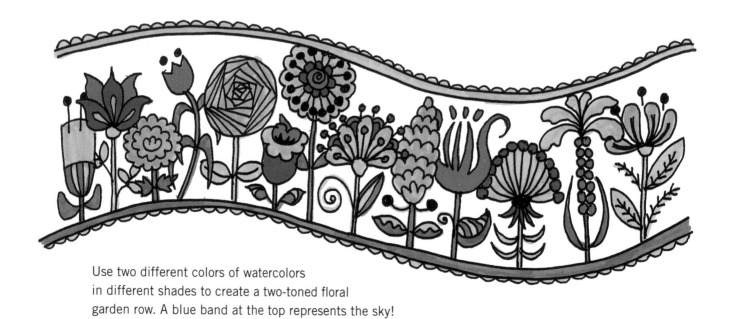

Use two different colors of watercolors
in different shades to create a two-toned floral
garden row. A blue band at the top represents the sky!

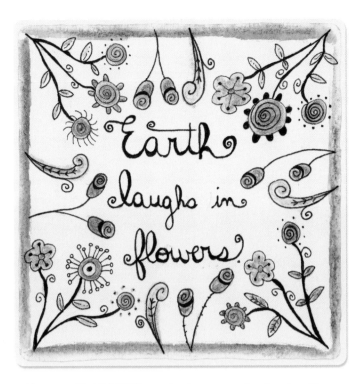

Use an .01 MICRON pen to draw a garden border. Then use Inktense watercolor pencils to color the design.

BY DAWN MEISCH, CZT, ONCEUPONATANGLE.COM

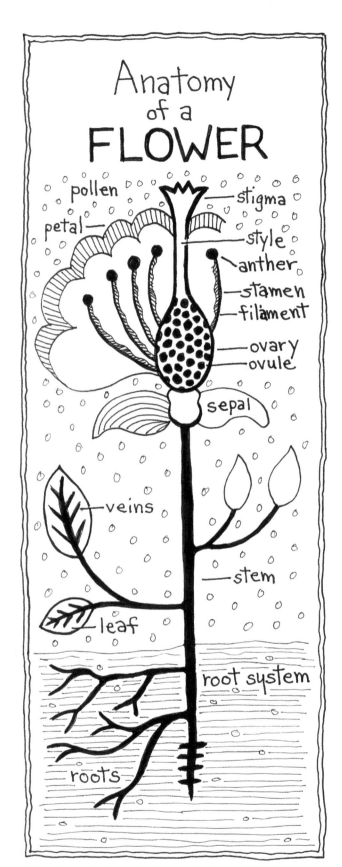

Anatomy
of a
FLOWER

pollen

petal

stigma

style

anther

stamen

filament

ovary

ovule

sepal

veins

leaf

stem

root system

roots

Your floral designs don't have to be realistic by any means, but by studying the structure of a real flower, you can get ideas of ways to modify designs and create new ones. This drawing was inspired by an old botany book.

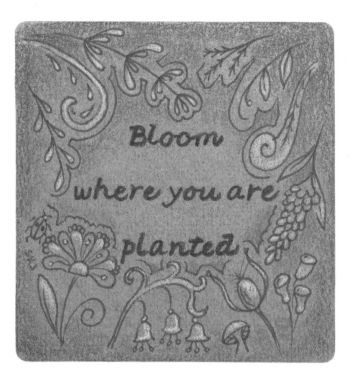

Choose a colored paper tile and draw designs with
a pen of a similar color to the tile. Use Prismacolor
pencils in colors for shading and in white for highlights.
Note: Sue's colorful tiles can be purchased on her blog.
BY SUE JACOBS, CZT, SUEJACOBS.BLOGSPOT.COM

Project: Painted Box

This chalkboard-esque box flips traditional drawing designs on their head by making them pop by using white on a dark background. Even an inexpensive wooden box looks like a million bucks once you give it this special treatment.

PROJECT BY KATHRYN ERNEY

Materials

- Box (wood, plastic, etc.)
- Black acrylic paint or spray paint
- White acrylic paint
- Wide- and fine-tipped paintbrushes
- Protective enamel spray

1 **Paint the box.** Paint the entire box black using either spray paint or acrylic paint and a wide-tipped paintbrush. Allow the paint to dry.

2 **Sketch the design.** Sketch your design on the box with a graphite pencil (if it shows up on the black) or a white colored pencil.

3 **Paint the design.** Trace the design with white paint using a fine-tipped brush. If you want to create a raised, puffy effect, go over the lines several times. Allow the paint to dry.

4 **Finish the box.** If desired, protect the finished box with a protective enamel spray suited for painted surfaces.

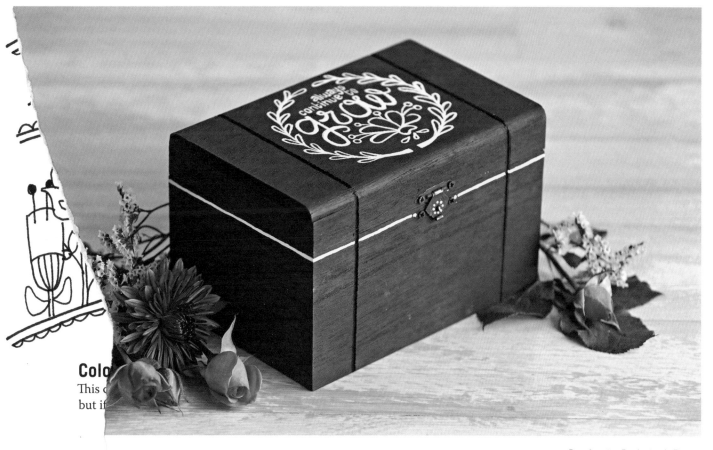

Colo
This
but i

Vines

These twining and flowing tendrils make great borders for cards, art, and more.

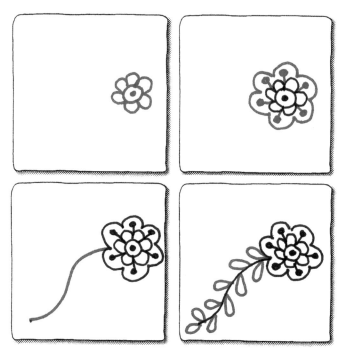

1. Start a flower.
2. Add to the flower.
3. Add a vine.
4. Add leaves to the vine.

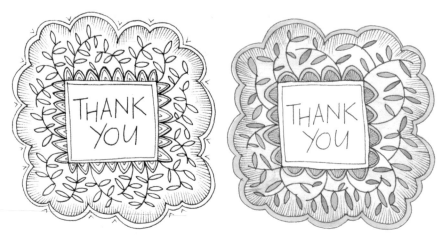

It's easy to create thank-you notes in just minutes. Draw a box and write "Thank You" in simple letters in the box with an .01 MICRON pen. Draw a scallop around the box. Draw a large scalloped shape to create a new outer edge to the design, and then fill the space with vines. Shade or color as desired with color pencils.

BY C.C. SADLER, CZT, LETTERINGANDTANGLING.

SQUARESPACE.COM

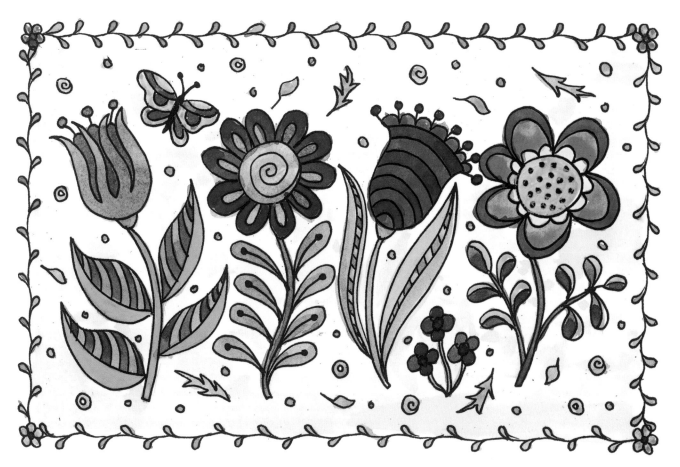

Vines form a perfect, delicate border for this watercolored piece.

Holiday Vines

Use fine-tipped pens and markers to build holiday decorations out of simple vine shapes! From holly to trees to snowflakes, you're sure to spread some seasonal cheer. Try watercolor backgrounds behind snowflakes or in the delicate snowflake crystals; use vivid reds to make pops of berry in wreaths and holly; and add bright, glowing stars to the tops of trees.

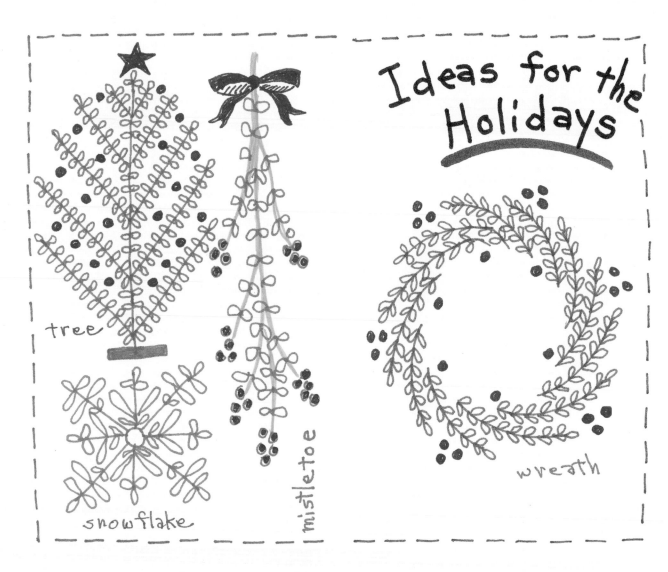

tree

snowflake

mistletoe

Ideas for the Holidays

wreath

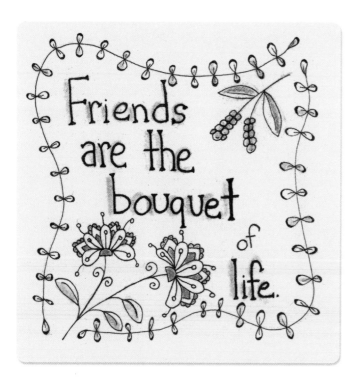

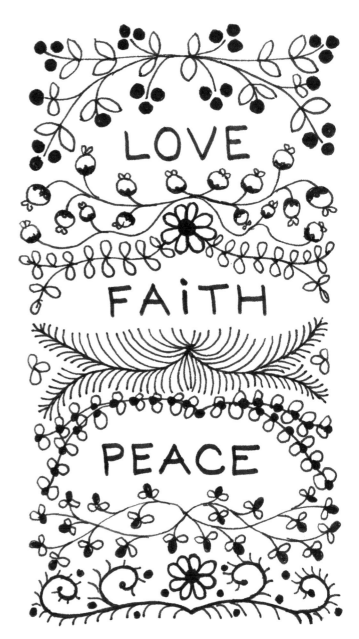

Friends brighten our days just like a fresh bouquet of flowers. For a piece like this, use one type of vine as a border and some larger flowers as focal points. Use an .01 MICRON pen.

BY DAWN MEISCH, CZT, ONCEUPONATANGLE.COM

Use a fine-tipped pen, like an .05, to draw the vines, and then write words in the spaces with an .08 pen.

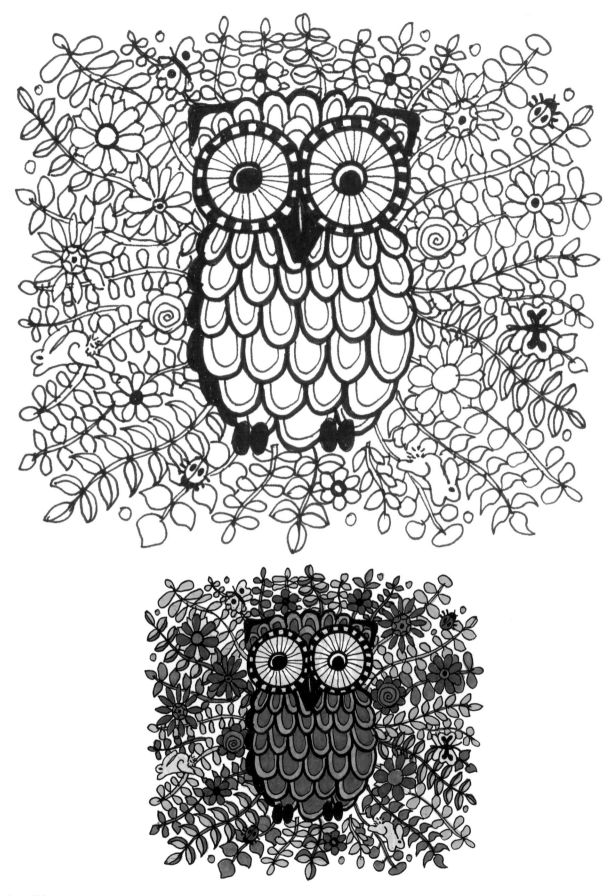

Color It!

Here is one owl already colored for you. Let the colored
owl inspire you, and enjoy making your own owl unique.

Project: Decorated Mugs

You can make a personalized dish set in just a day! All you have to do is decorate your dishware with marker and bake to set the designs. You'll be eating off floral plates and drinking from organic mugs in no time!

Materials

- Inexpensive ceramic mugs/plates/other dishware
- Oil-based permanent markers such as Sharpies or DecoArt glass paint markers
- Home oven

TIP
It is best to hand wash these decorated dishes.

1 **Prepare the mug.** Clean the mug of any residue or fingerprints. Shake the paint marker well. Activate the paint inside the pen by pressing down on the tip until color appears. Practice the design you want to draw on a piece of paper.

2 **Draw the design.** Draw your design on the mug with the marker. When you're done, allow the ink to dry for 8 to 12 hours.

3 **Bake the mug.** Put the mug in a cold oven and set the oven to 375 degrees Fahrenheit. Allow the mug to bake for about 40 minutes (counting from when you put it in the oven).

4 **Cool the mug.** Once the time is up, turn the oven off and allow the mug to cool to room temperature inside the oven. This will take a while, but will ensure that your mug won't crack.

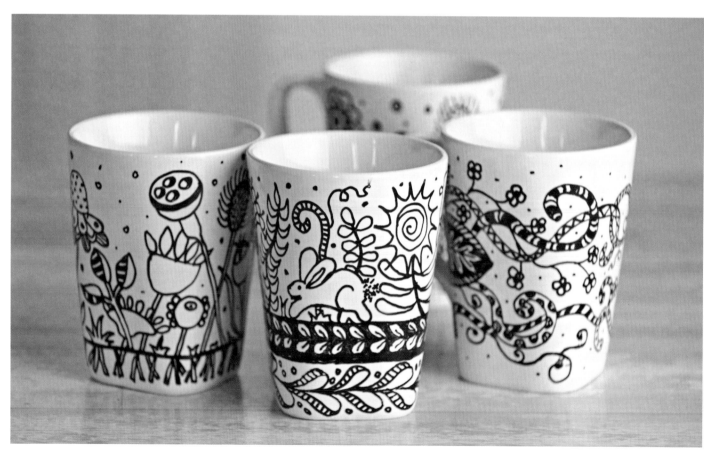

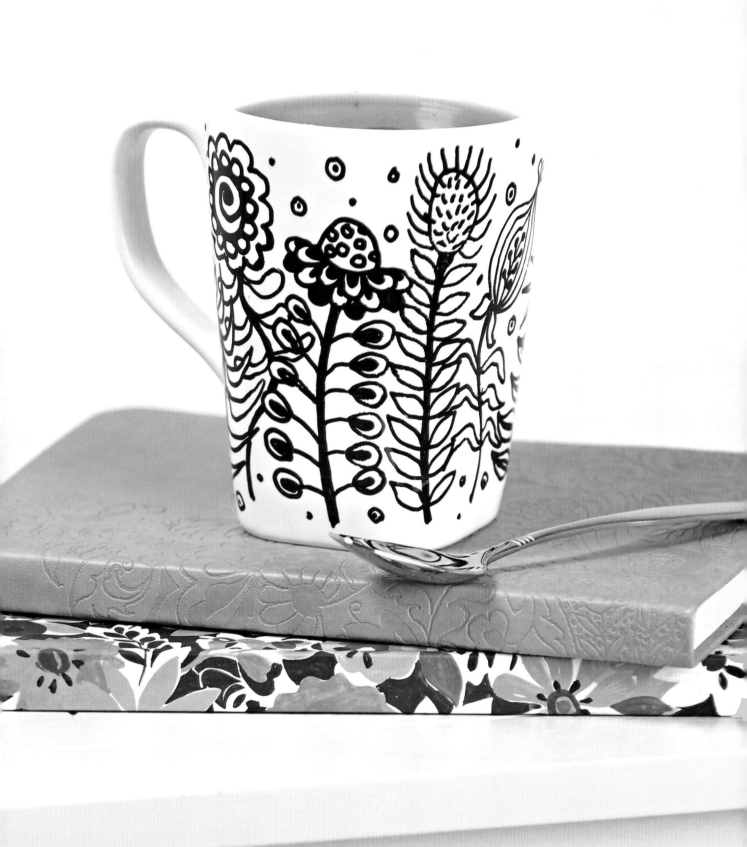

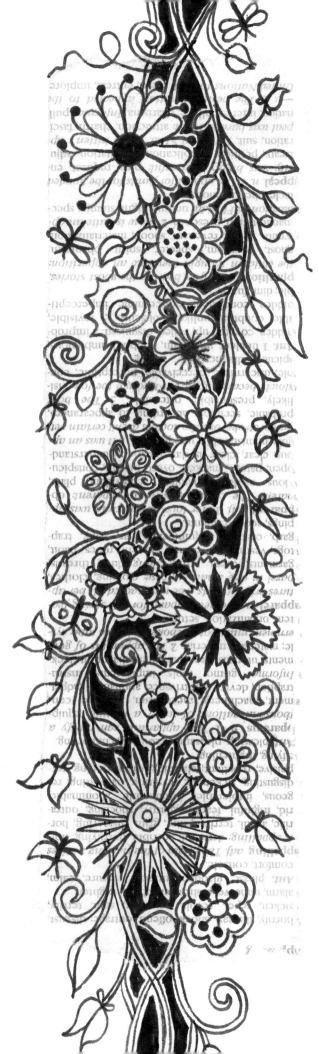

Petals

Create a garden with petals that grow into beautiful works of art.

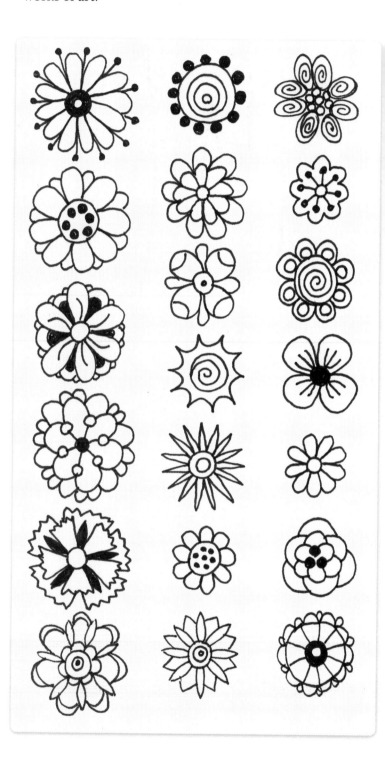

Mixed media is fun to try. This design was drawn on top of a dictionary page.

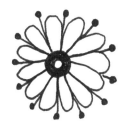

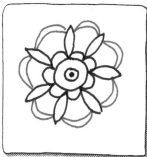

1. Start with a circle with basic embellishments.
2. Add longer embellishments.
3. Connect the longer embellishments.

An attitude of gratitude leads to a happy life. Draw flowers with an .01 MICRON pen. Write "Thank You" in the center. Use Prismacolor pencils to color the background.

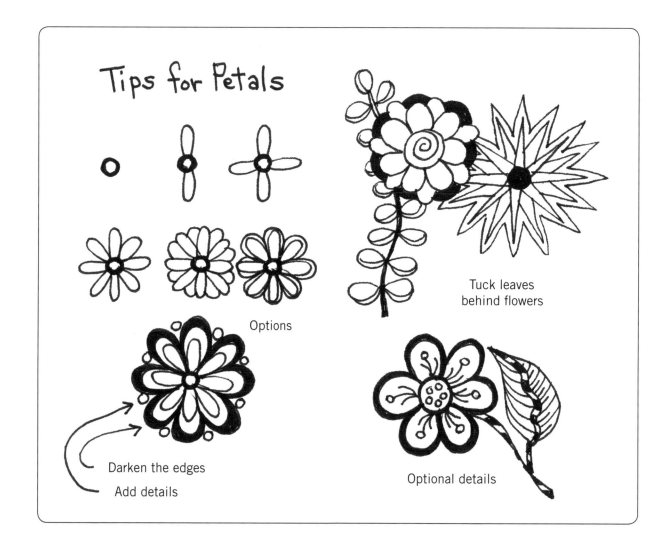

Tips for Petals

Options

Tuck leaves
behind flowers

Darken the edges

Add details

Optional details

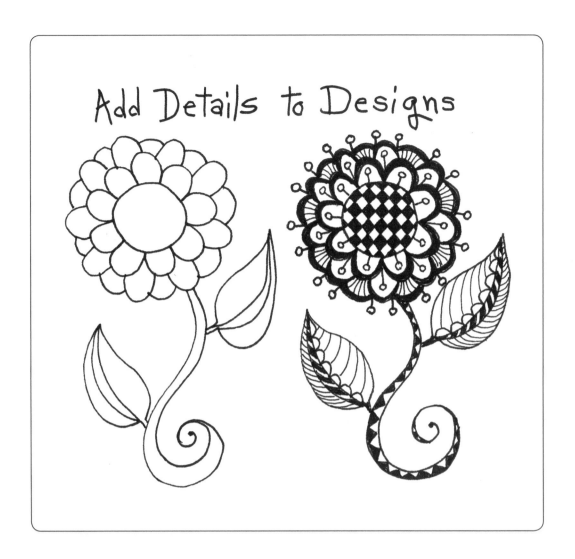

Add Details to Designs

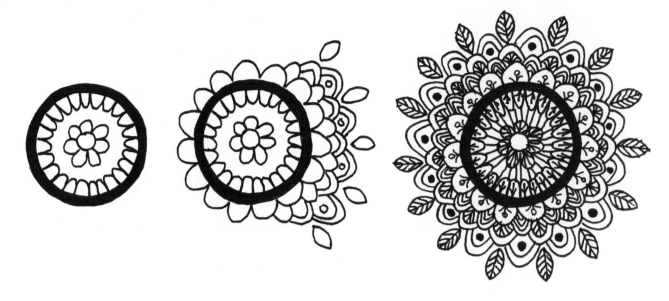

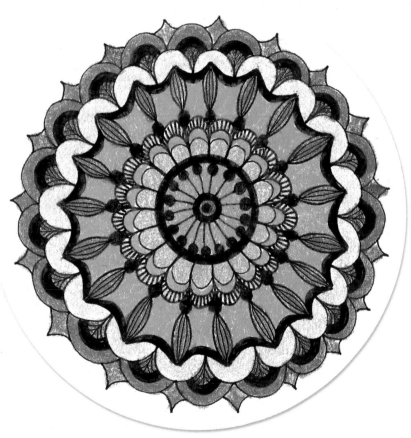

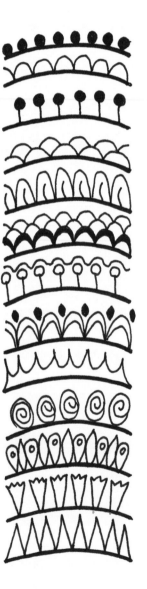

Make a Petal Mandala

Layer upon layer of petals can transform a simple shape into an ornate, beautiful petal mandala. Start with a basic shape and basic details, like the first step above. Then start adding repetitive rows of new details until you have built a dense, amazing petal mandala like last step above. Don't think—just relax and draw. Your mandala will grow with each row of details. Enjoy the process. Take a look at the petal possibilities shown on this page, and don't be afraid to add color, too!

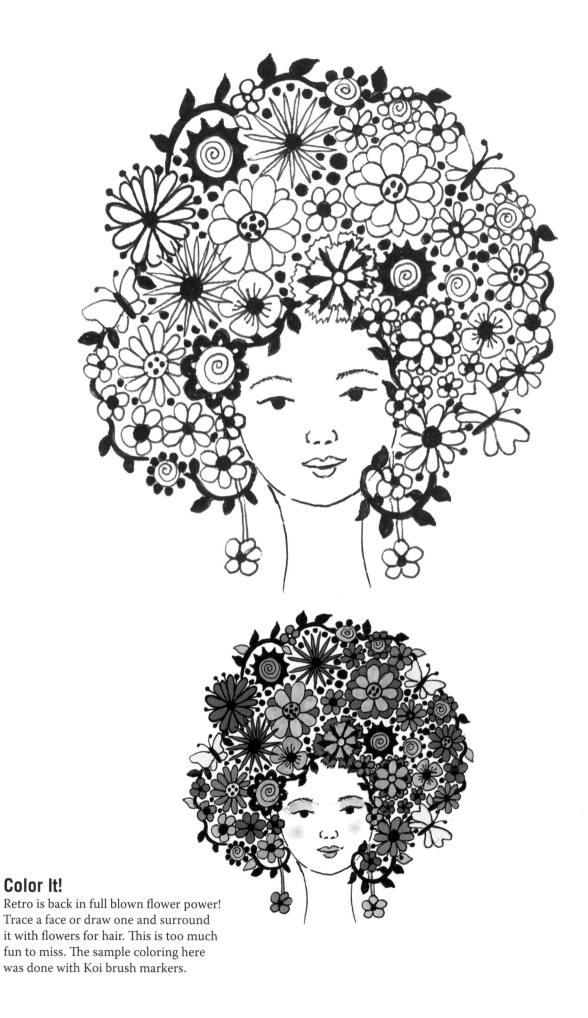

Color It!

Retro is back in full blown flower power!
Trace a face or draw one and surround
it with flowers for hair. This is too much
fun to miss. The sample coloring here
was done with Koi brush markers.

Project: Painted Tote Bag and Shirt

Special pens like bleach pens and paint pens make drawing designs right onto fabric a cinch. The techniques are similar, but have a few differences that are explained below. Have fun customizing clothing, bags, and more!

PROJECT BY KATHRYN ERNEY

Materials

- Canvas tote bag
- Paint pens/ fabric markers
- T-shirt
- Bleach pen
- Fabric pencil/chalk
- Wax paper

TIP Not all fabrics bleach equally! If you can, test the fabric you want to bleach inside a seam first. However, your best bet may be to just go with the flow and see what happens!

1 **Sketch the designs.** Sketch your designs with fabric pencil or chalk on both the bag and the shirt. On the shirt, make sure the lines are spread out, as the bleach pen will make thick lines (fine detail is hard to achieve).

2 **Decorate the bag.** Use the paint pens to decorate the bag. Allow the paint to dry. Depending on the pens you use, you may need to heat set the design with an iron—read the manufacturer's instructions for your particular pens.

3 **Prep the shirt.** Put several layers of wax paper between the layers of the shirt to prevent the bleach from bleeding through. You can also tape the wax paper to a piece of cardboard.

4 **Decorate the shirt.** Use the bleach pen to decorate the shirt. Let the bleach design sit for about 10 to 15 minutes, then wash the bleach off thoroughly in the sink and run the shirt through the wash.

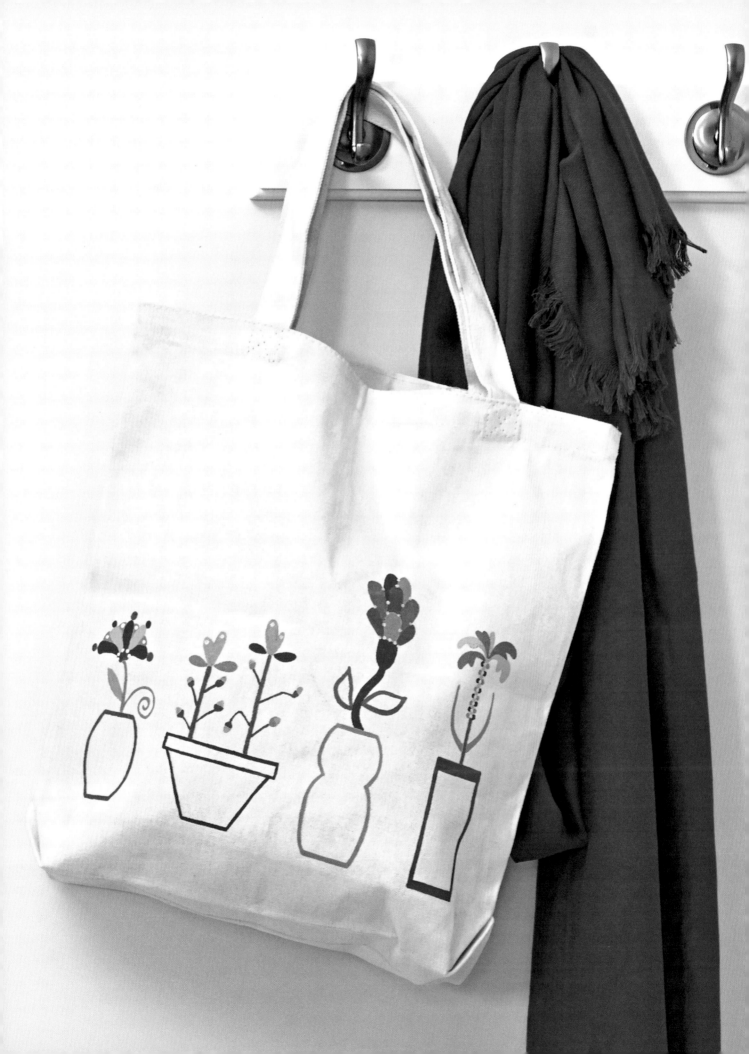

Leaves

Whether you color them "naturally" in greens and oranges or go fantastical, leaves are an essential part of nature designs!

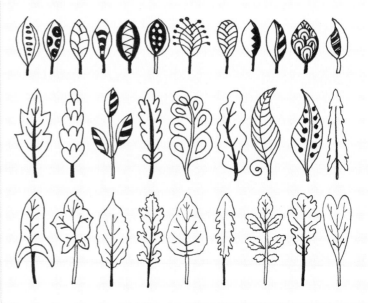

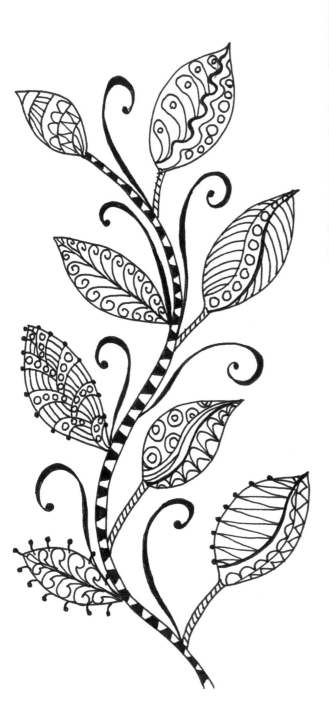

1. Draw the leaf's center.
2. Add spikes.
3. Add an outline.

Feel free to add diverse, dense designs inside each leaf.

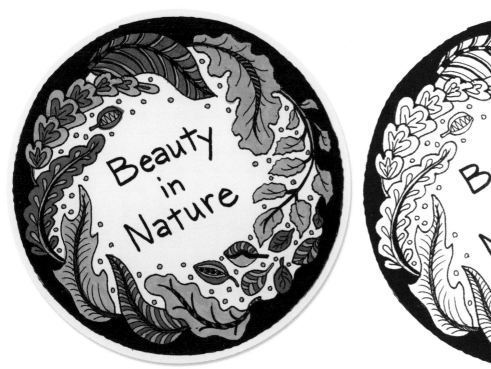

These leaves, colored with brush markers,
form a beautiful spiral around the message.

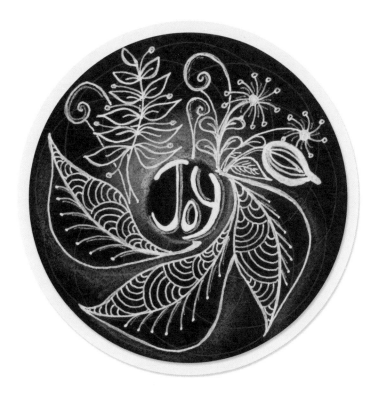

White ink on black creates a perfectly peaceful, frosted look. Write a word in the center of a circular black paper tile with a white gel pen such as Sakura's Gelli Roll pen. Draw designs around the word.

BY BARB ROUND, CZT, BARBROUNDCZT.WEEBLY.COM

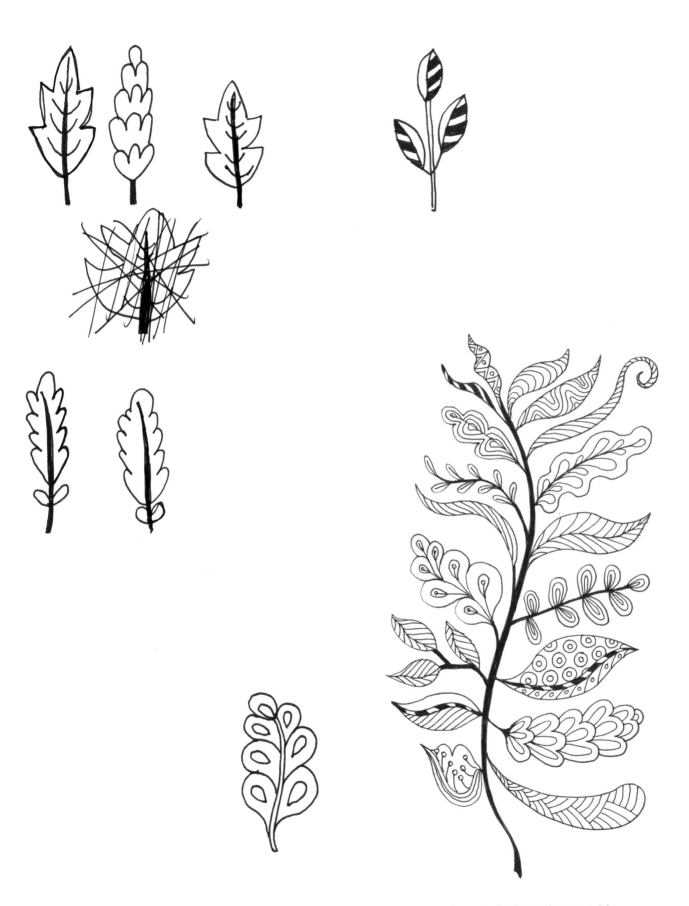

Leaves don't need to match!
It's your art world.

How Leaves Grow

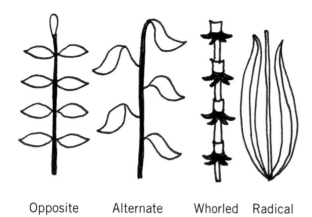

Opposite Alternate Whorled Radical

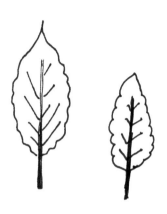

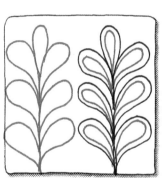

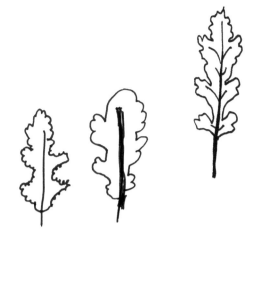

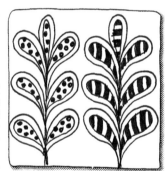

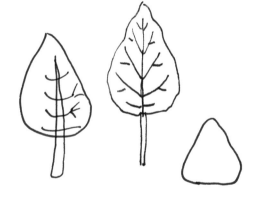

Fill in basic leaf shapes with patterns.

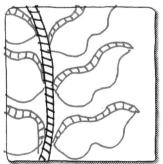

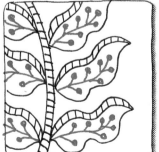

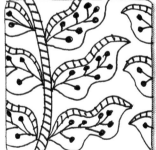

Even complex-looking leaves are really just a series
of simple steps.

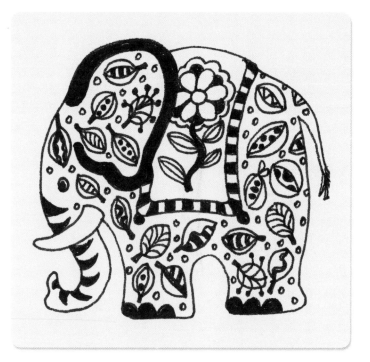

For this elephant, you can use an .05 MICRON pen to draw the details and to fill in dark areas.

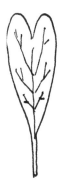

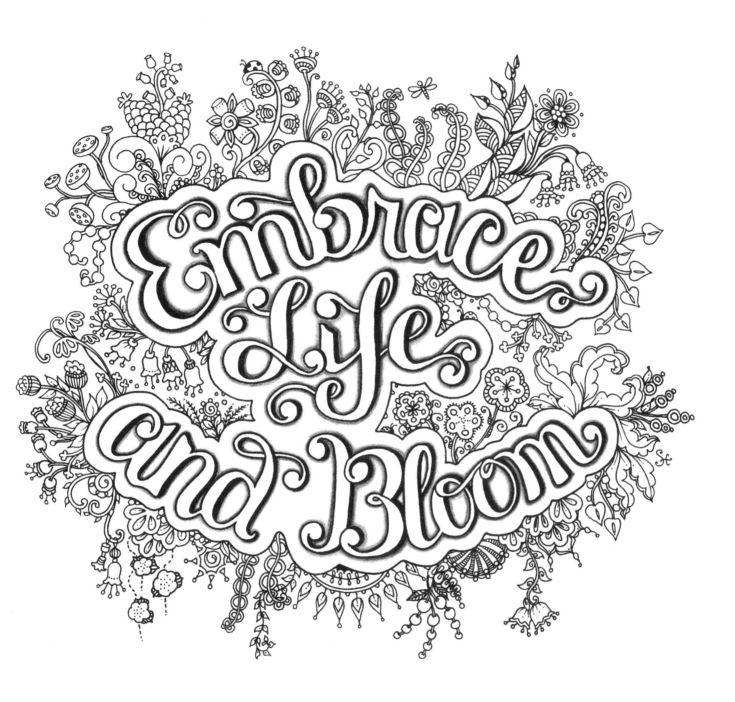

Color It!

Start with your own handwriting using an .005 MICRON pen. Add curls where you think they look good. Add shadows to the lines. Using an .02 MICRON pen, darken the lines that are made on the downstroke. Add FloraBunda designs all around with an .005 MICRON pen. Add shading around the outer border with a 2B pencil.

BY SANDY HUNTER, CZT, TANGLEBUCKET.BLOGSPOT.COM

Project: Bound Sketch Journal

You can make your own hand-bound sketch journal to either use for your own daily musings or to design with someone in mind and give as a gift! The steps are the same—it's just a question of what to do with the pages.

Materials
- 7" x 10½" (18 x 27cm) piece of 140# watercolor paper for each page (Fabriano HP smooth is best)
- Black .05 MICRON pen or other similar pen
- Color markers, such as Tombow markers
- Watercolors and paintbrush
- Pointed awl
- Large tapestry needle
- Waxed linen thread

DESIGN IDEA Use a pen to draw designs on the pages of your book, and add color with markers or watercolors. For day-by-day style pages, draw columns on the pages with the dates or days of the week. Write and draw a short description of what you did each day.

1 **Prepare the pages.** Tear or cut four sheets of watercolor paper. Fold each page in half; use a bone folder if you have one for a crisp fold. Open the pages up again and stack them.

2 **Punch the holes.** Use an awl to punch five holes down the fold. Space the holes evenly about 1" (2.5cm) apart.

3 **Bind the book.** Thread a needle with 18" (45cm) of thread. Beginning at the third hole from the bottom, bring the thread up through the hole from the bottom of the stack.

4 **Finish binding.** Go in and out through the holes all the way to the top, then back down through again to the bottom, and then back up one more time to the center (you'll pass the thread through most holes twice). Tie a secure knot with the ends of the thread. Cut the thread tails as short as you want.

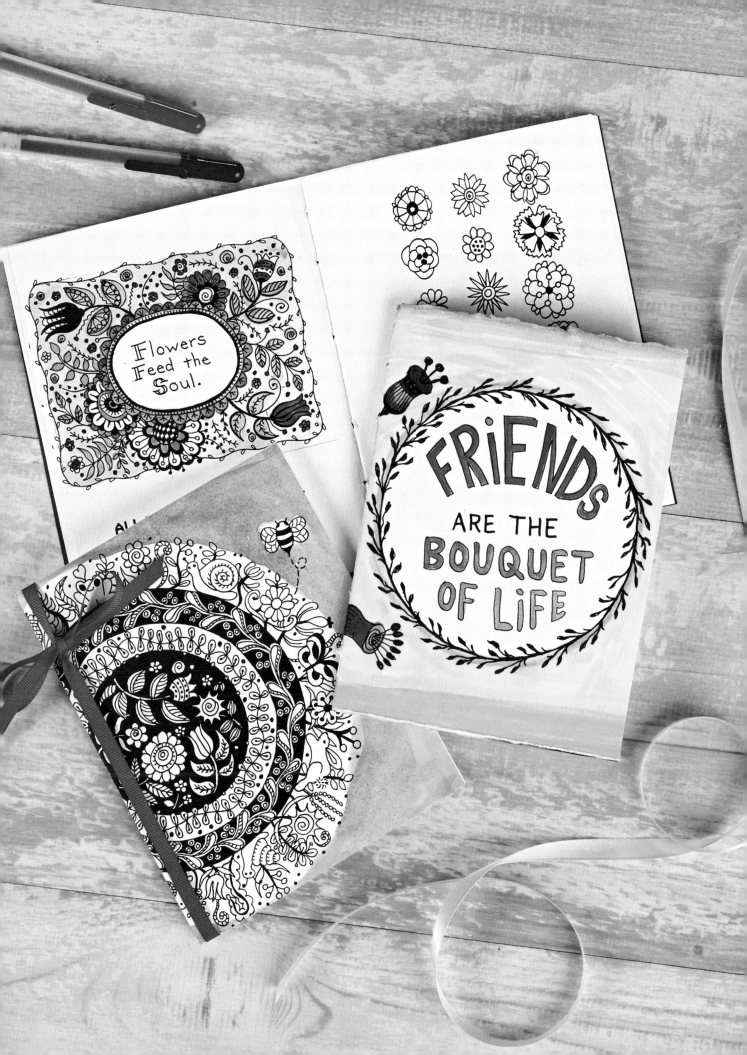

Pods

Discover an amazing assortment of pod shapes flourishing with nature's plenty.

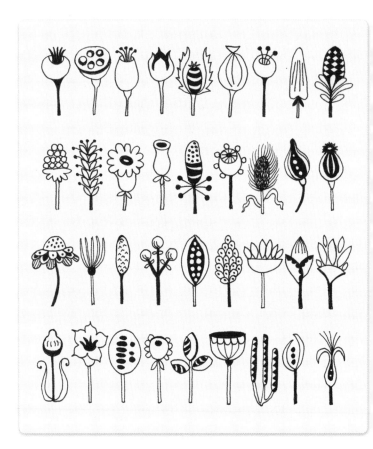

This flower-like pod was colored with watercolors and has lots of friendly creature accents.

1. Draw a circle.
2. Draw a bigger circle that hugs the first.
3. Add the stem and spikes.

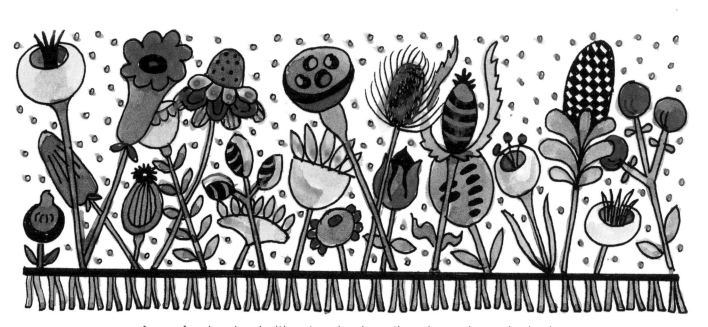

A row of pods colored with watercolors in earthy colors makes a nice border.

Adding Details and Tangles

Draw circles, swirls, dots, stems, squiggle lines, or scrolls.

Draw parallel lines, veins, dots, or checkerboard patterns.

Fill shapes with zigzags, humps, parallel lines, dots, or stripes.

Add parallel lines (horizontal, vertical, or diagonal), stripes, checkerboard patterns, or dots.

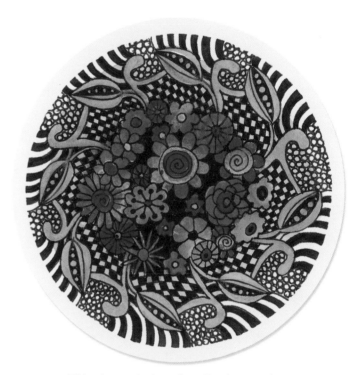

This dense design gives the impression
of endless growth.

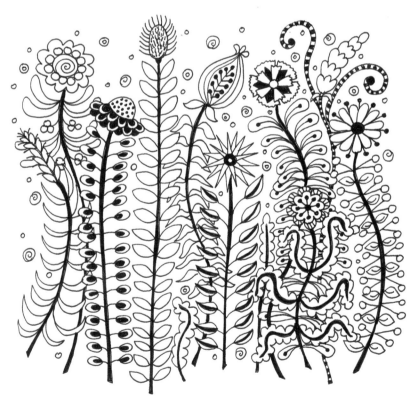

Try incorporating vines as stems for your pods.

Steps to Fill a Space

1. Draw large flowers

2. Add medium leaves

3. Add small shapes

4. Add tiny icons

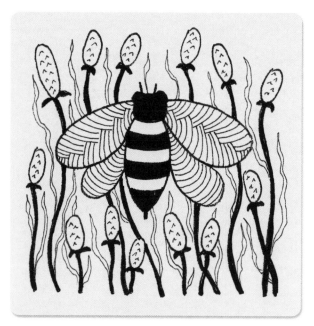

A bold bee makes a great foreground for a repetitive pod background.

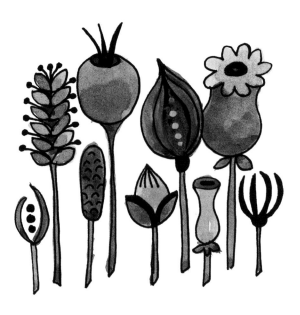

This design was done in watercolors and features .05 and .08 pens.

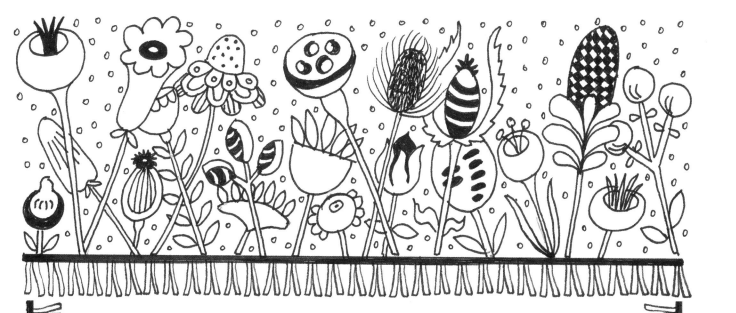

If FRIENDS were FLOWERS
I would PICK YOU

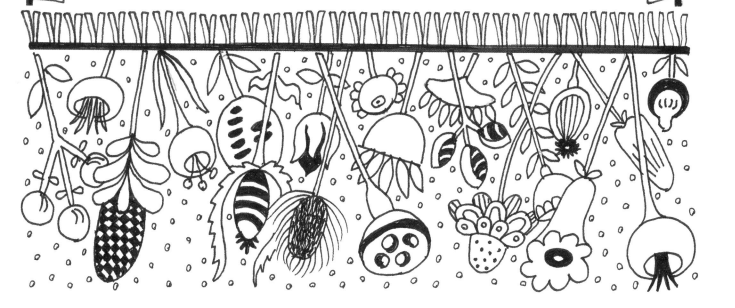

Color It!
A repeated image can give a larger piece great symmetry.
Add a sentiment, and you have a frameable gift!

Project: Wall Art

Whether you use a piece of art from this book or create your own, an inspirational quote framed with flowing FloraBunda art is sure to brighten your day as much as sunshine. The designs, the color scheme, the sentiment—they're all up to you!

PROJECT BY MARIE BROWNING, CZT

Materials
- Pens and markers
- Frame
- Copier

1 **Draw the design.** Copy any desired design from this book onto a clean sheet of paper, or draw your own framing art, leaving space for a quote.

2 **Color the design.** Color the design with markers or other pens.

3 **Write the message.** Hand letter an inspirational quote or message inside the design.

4 **Finish the piece.** Mat (if desired) and frame the colored art, then hang it up on a wall.

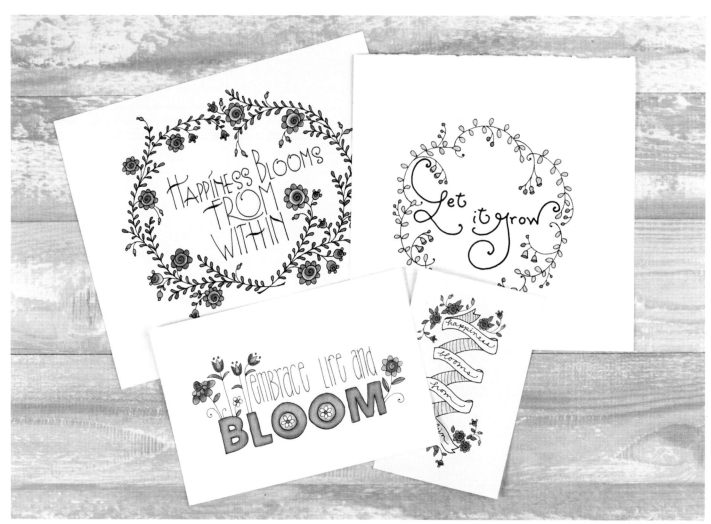

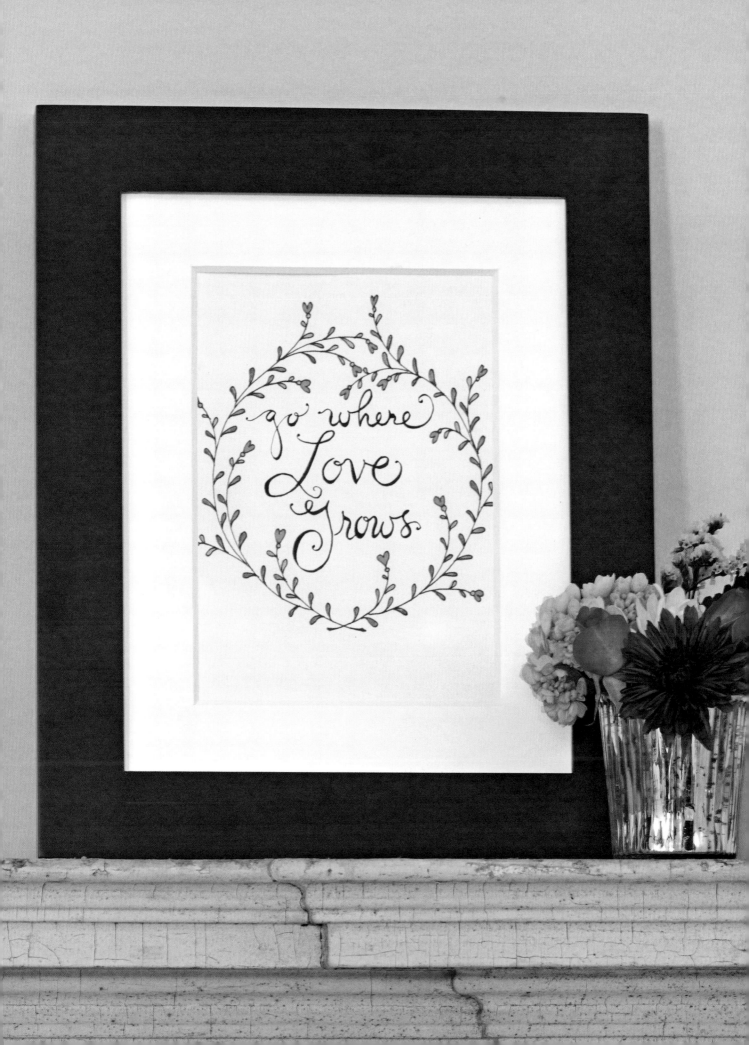

Growth

Drawing creeping tendrils, unfurling ferns, and glorious growing things can rejuvenate your creativity.

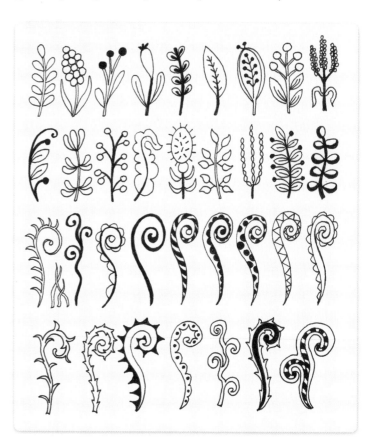

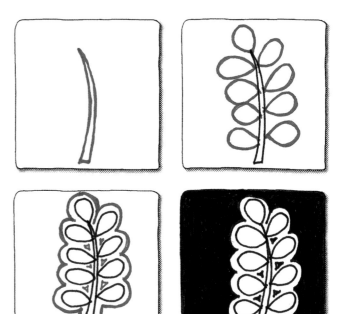

A black background makes these designs really pop. Check out the gourd project, which uses this style, on page 110.

1. Draw the stem.
2. Draw bubble leaves.
3. Outline the bubble leaves.
4. Color in the background.

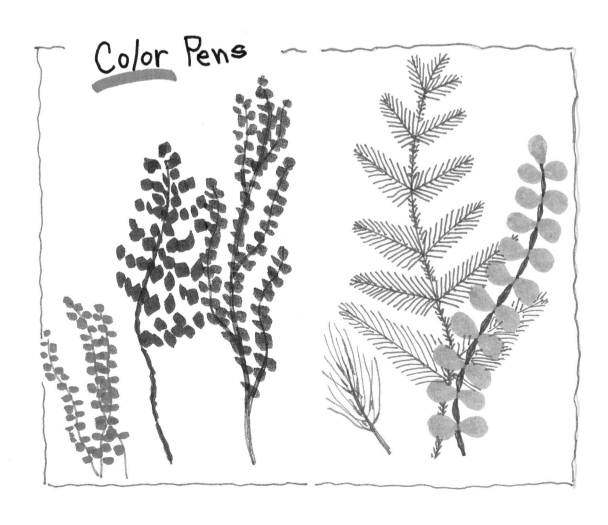

Color Pens

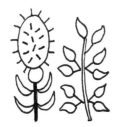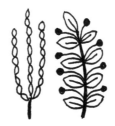

Ferns always start with the basic shape of the spine.

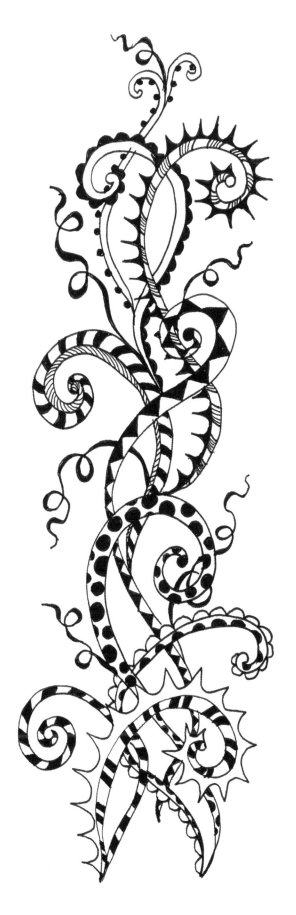

Tendrils of growth can extend endlessly,
or as long as you want them to.

Pots and Containers

You can get creative with the things your flowers and plants live in, as well! Make your man-made pots into fitting companions for the beautiful natural designs.

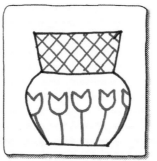
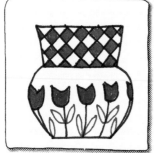
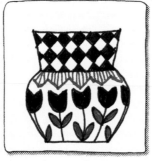

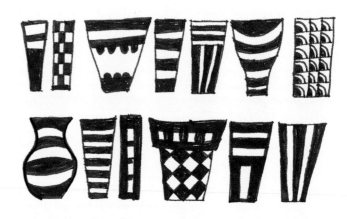

Pretty pots make good anchors for your floral designs.

Complicated pot designs aren't tricky—just build them up one pattern at a time.

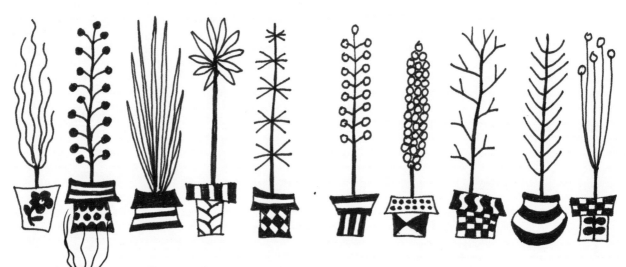

These designs look so nice and symmetrical all in a row.

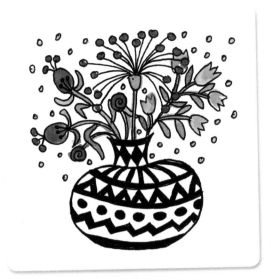

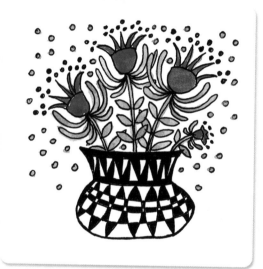

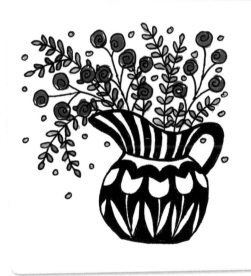

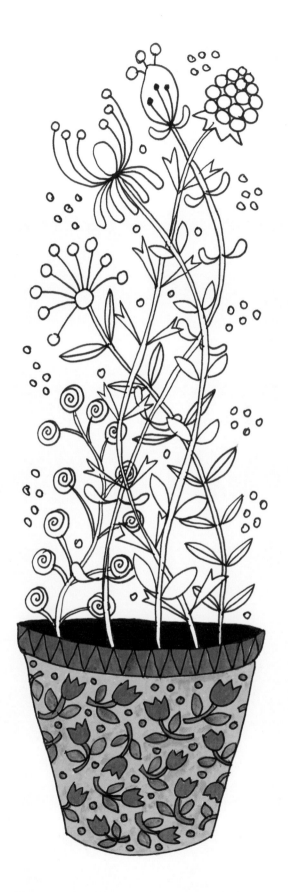

Black and white pots make the flowers that live in them really stand out—in real life as well as in art!

If you want to focus on the cute pot design, make a daring color choice.

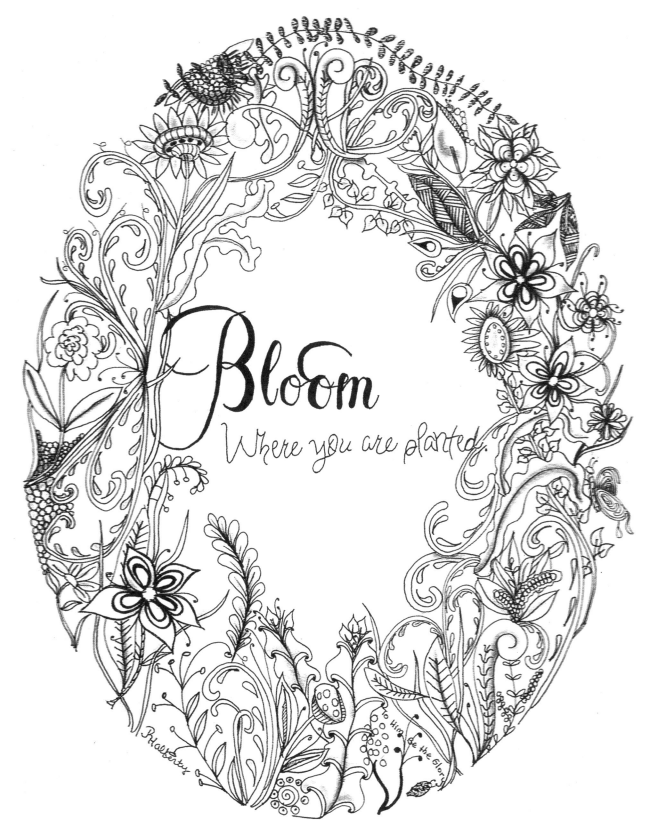

Bloom
Where you are planted.

Color It!

Wispy vines, flowers, and leaves are perfect on this card. Trace around an oval to create the center space. For lettering, trace computer-printed words onto Bristol vellum paper using graphite transfer paper. Alternatively, you can handwrite words. Use an .01 MICRON pen for drawing the designs.

BY JODY HALFERTY, CZT, JODYHALFERTY.COM

Project: Woodburned Box

Woodburning requires a special tool that you'll have to purchase or borrow, but the art that results is worth the investment. You don't need a fancy, expensive box to decorate—a plain box will come to life under your pyrography tool! Just make sure to read all the manufacturer's safety instructions before beginning.

PROJECT BY MICHELE PARSONS

Materials
- Wooden box
- Woodburning tool or set

1 **Practice.** If you aren't familiar with woodburning tools and techniques, practice using the tool on a scrap piece of wood before working on the box.

2 **Prepare the box.** Prepare the box by cleaning it of any residue and sanding off any finish that is already on the box.

3 **Sketch the design.** Use a pencil to draw the design you want to woodburn on the box.

4 **Burn the design.** Carefully trace over your design with the woodburning tool. Use different woodburning tips (if you have them) to create different lines and shading.

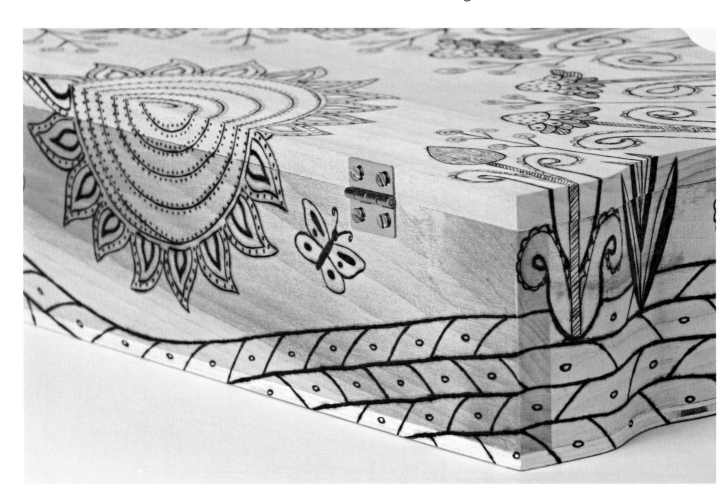

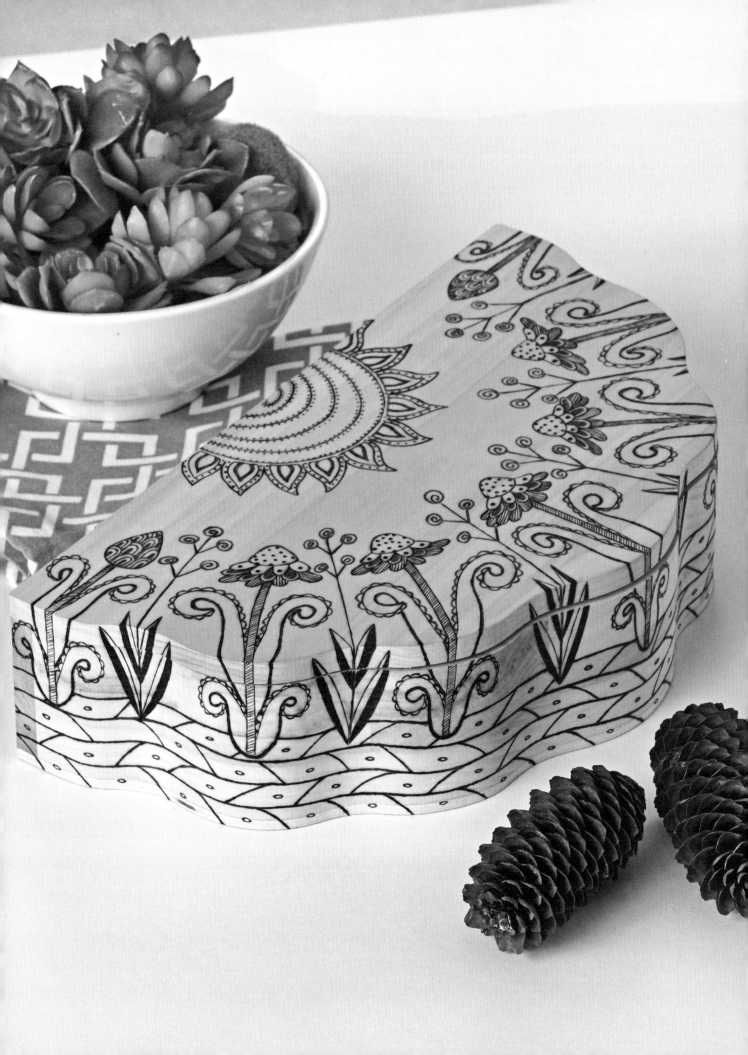

Buds

Buds are delightful accents on flowers. Tuck them into small spaces or let them peek out from behind leaves.

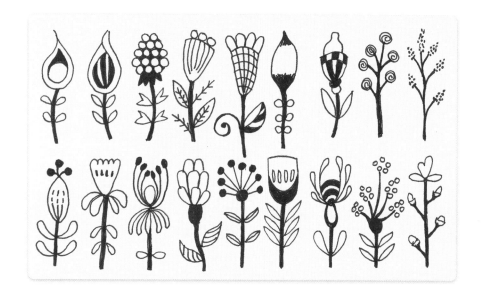

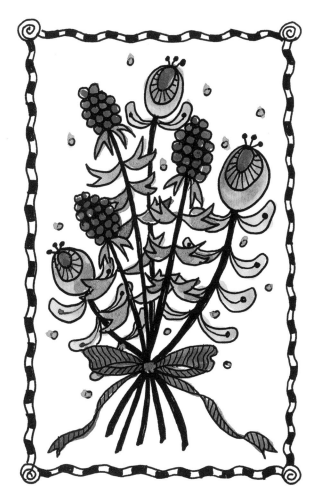

Add a simple ribbon to a bunch of watercolored buds for a pretty finished look.

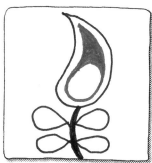

1. Draw the outline.
2. Fill in the shape.

1. Start with the central shape.
2. Add embellishments around the center.

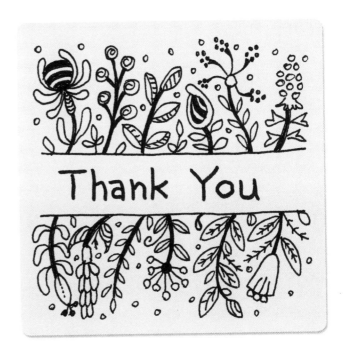

Straight lines make good contrast for organic, flowing designs.

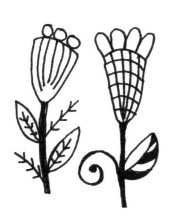

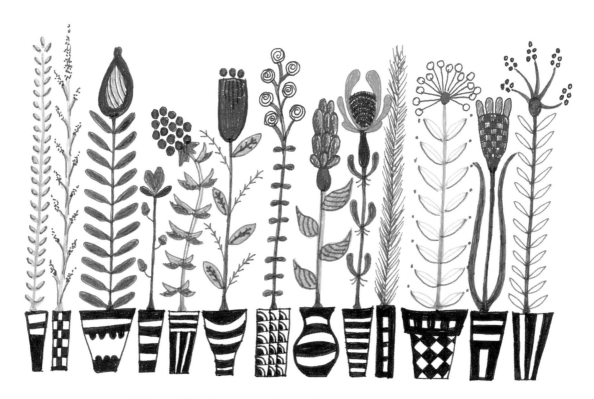

These tall designs were drawn with colored pens.

Mix buds, growth designs, and petals with simple dots and lines for a lush effect.

A scattering of buds and a witty saying combine for a perfect art tile.

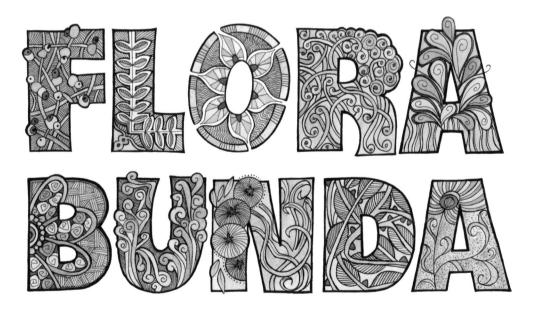

Color It!

Enjoy coloring this dense piece of word art. Declare your love for whatever you like by following this example to create living words!

BY C.C. SADLER, CZT, LETTERINGANDTANGLING.SQUARESPACE.COM

Project: Leather Cuff Bracelet

Pick up some inexpensive leather snap bracelets at your local craft store and decorate them to make them personalized and beautiful. You'll soon be making more and more of them when you realize how easy they are!

Materials

- ¼" and ⅜" (0.5cm and 1cm) wide leather bracelets with snaps
- White acrylic paint
- Flat ¼" (0.5cm) paintbrush
- Graphic #1 black pen by Sakura or other similar pen
- Satin spray acrylic sealer

1 **Sketch the design.** Trace the shape of the leather bracelet onto blank paper so that you can work with the amount of space you have. Sketch the design you would like to put on the bracelet until you have it the way you want it.

2 **Prep the surface.** You can draw directly on the leather if you want to, or you can paint the bracelet first. To paint the bracelet, apply two thin coats of white paint onto the leather, making sure to paint carefully around the snaps. Allow the paint to dry.

3 **Draw the design.** Draw your design on the bracelet with a black pen. Also color the edges of the bracelet with the black pen. Allow the pen to dry.

4 **Finish the bracelet.** Spray a few very thin coats of sealer on the bracelet to protect it.

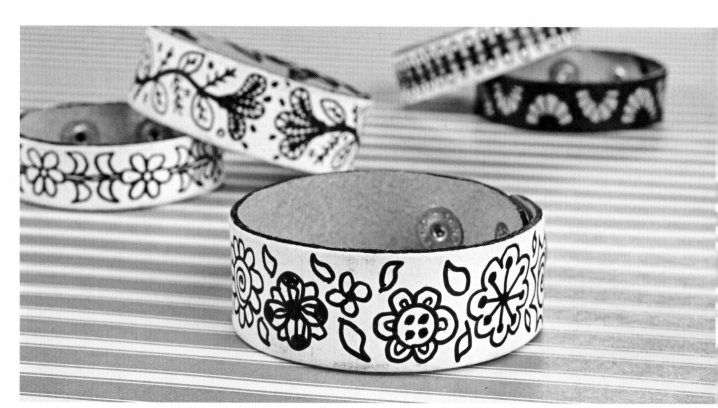

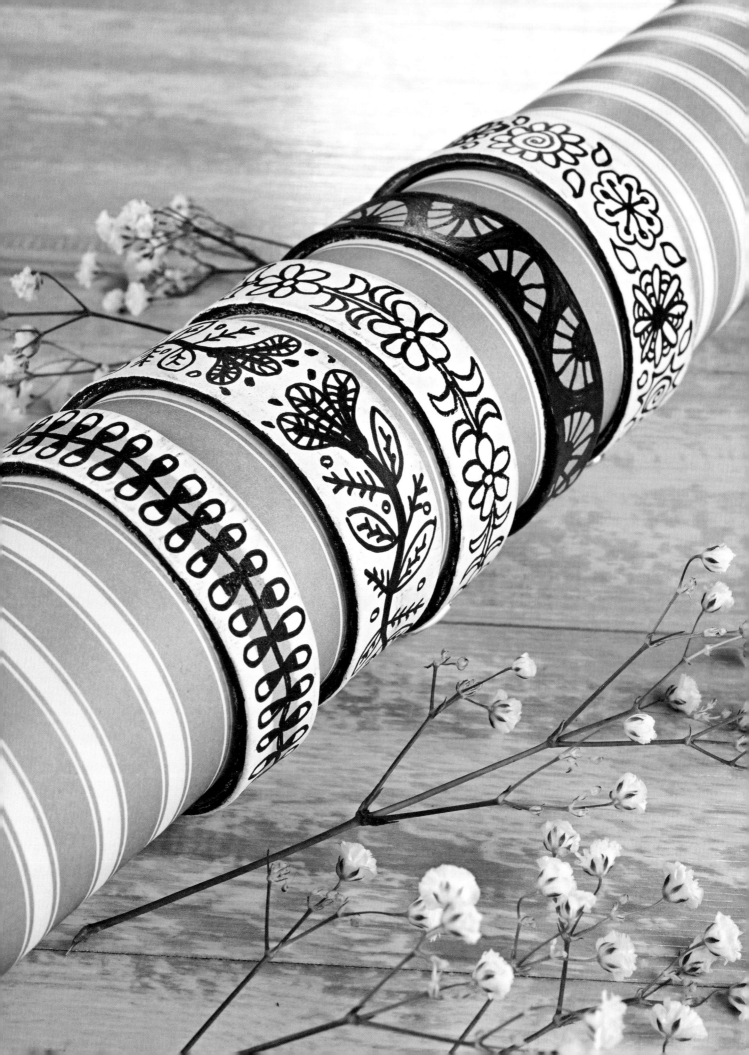

Bells

Many flowers have bell-shaped parts, like pitcher plants, dogbane, twinflower, corncockle, and bluebells—just to name a few.

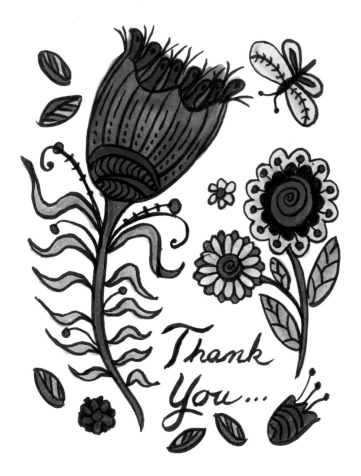

This card design doesn't actually use very many pieces, but still feels full and alive.

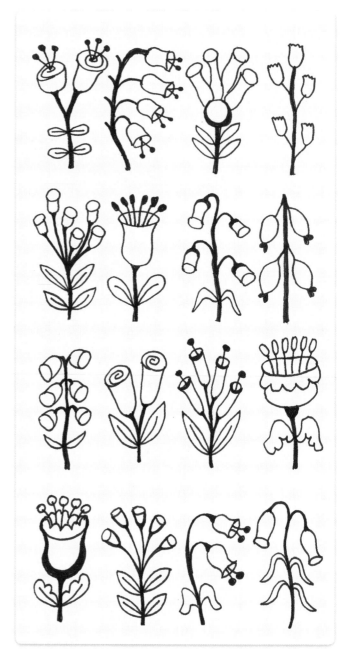

1. Draw the stems and the basic bell shape.
2. Add additional embellishments.

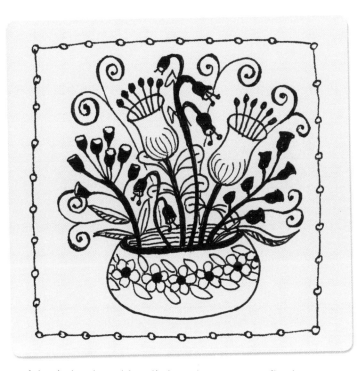

A basic border adds a little order to an overflowing pot.

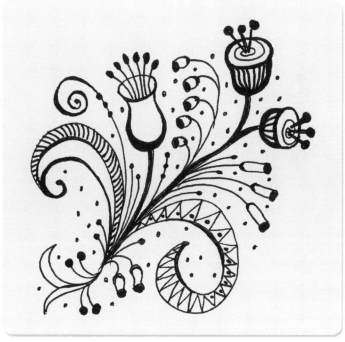

Just adding dots in the background of a design can make it seem more alive and moving—imagine that the dots are bits of pollen or petals fallen from the flowers.

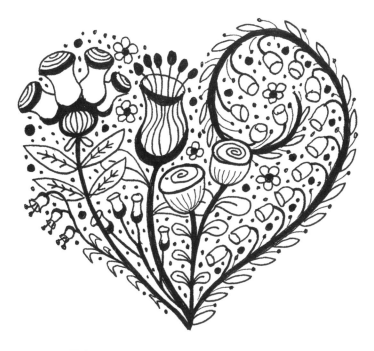

This heart made of bells was drawn with .05 and .08 pens.

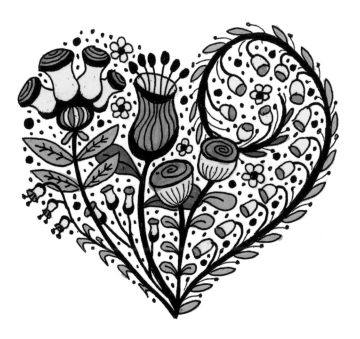

Choose just three colors for a cohesive and visually interesting feel.

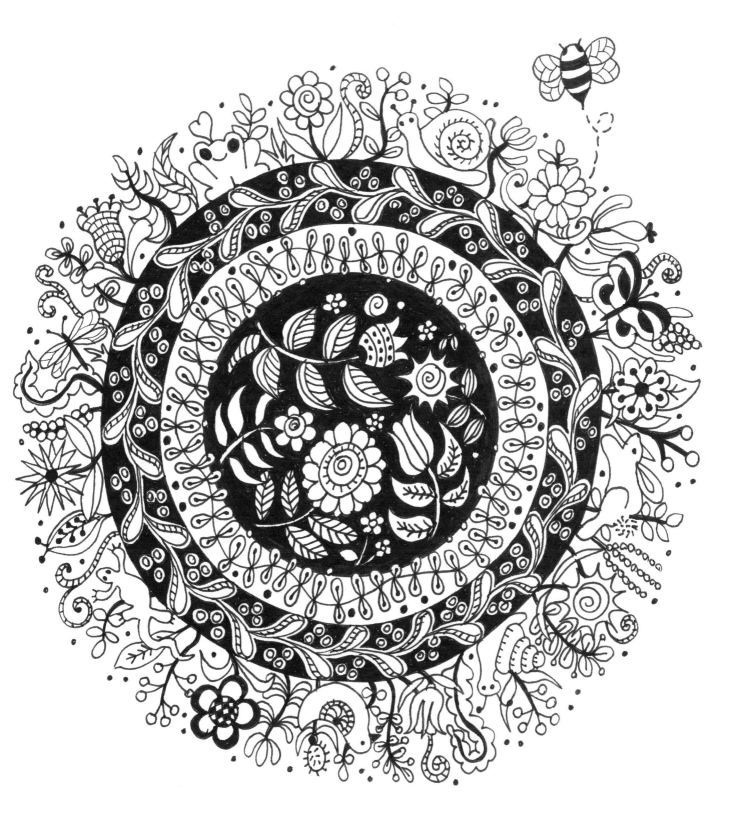

Color It!

You can see a colored version of this art on page 4.
Go more subtle or more vivid—it's up to you!

Project: Gift Tags

A homemade gift tag is a perfect finishing touch for presents, showing the recipient that you put extra care into the gift. You can make many gift tags quickly with just a few simple supplies, and how complicated the gift tag design is totally depends on what you want to do.

PROJECT BY MARIE BROWNING, CZT

Materials

- Cardstock
- Gel pens or other markers
- Ribbon or twine
- Hole punch
- Embellishments (optional)

1 **Cut the tags.** Decide how many gift tags you want to make and what shape they should be. Draw and cut them out of the cardstock.

2 **Draw the designs.** Draw your designs with gel pens or other markers. Make sure to leave a spot to punch the hole for the ribbon.

3 **Make the tie.** Punch a hole at the top of each tag and thread a piece of ribbon or twine to serve as the tie.

4 **Embellish the tags.** Add any extra embellishments you'd like to the tags. If desired, make a matching card or cards to go with the tags.

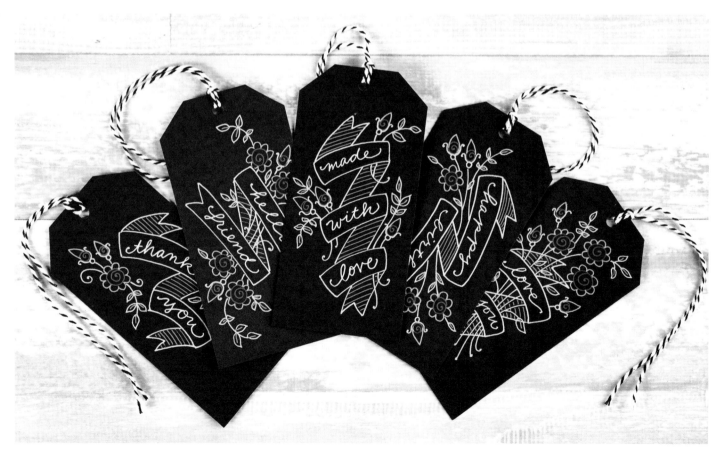

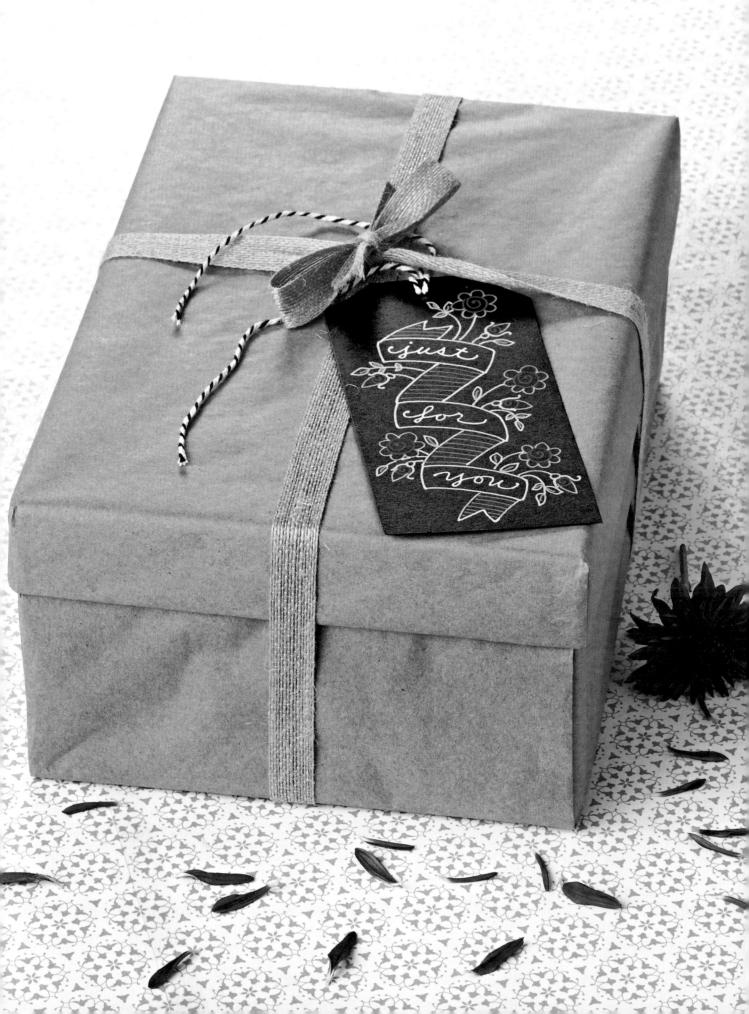

Accents

What's flora without some fauna? Welcome all species of charming creatures into your art.

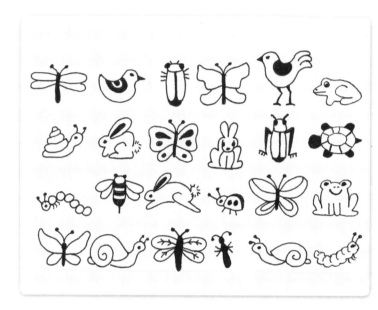

1. Draw the insect body.
2. Add the wings.

1. Draw the snail shell.
2. Draw the snail body.

Check out this tree that's home to so many critters! You can color and draw your own home tree on page 109.

Accents drawn purely with brush markers
are simple and soft.

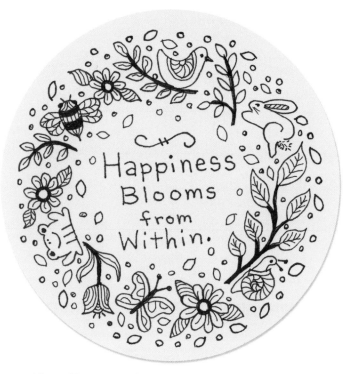

If you like, camouflaged animals can blend into the floral background just like real animals.

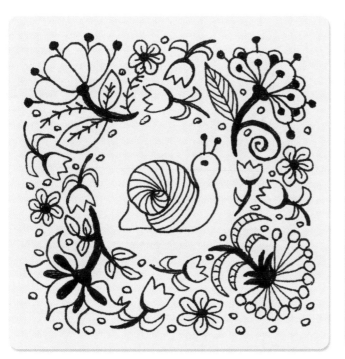

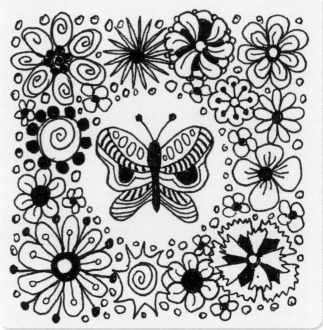

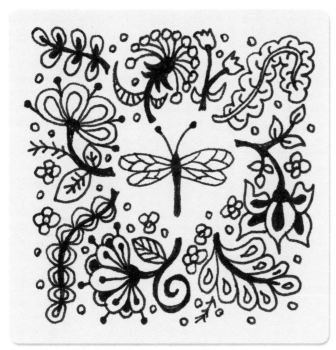

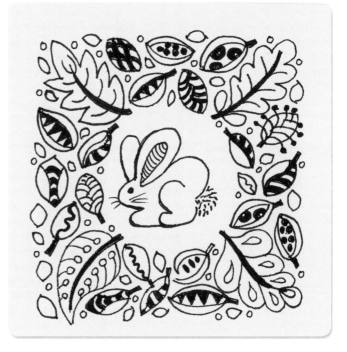

So sweet! Square tiles make a nice self-contained space to fill with designs and a central accent. Draw a critter in the center. Create a border with flowers, pods, leaves, and petals.

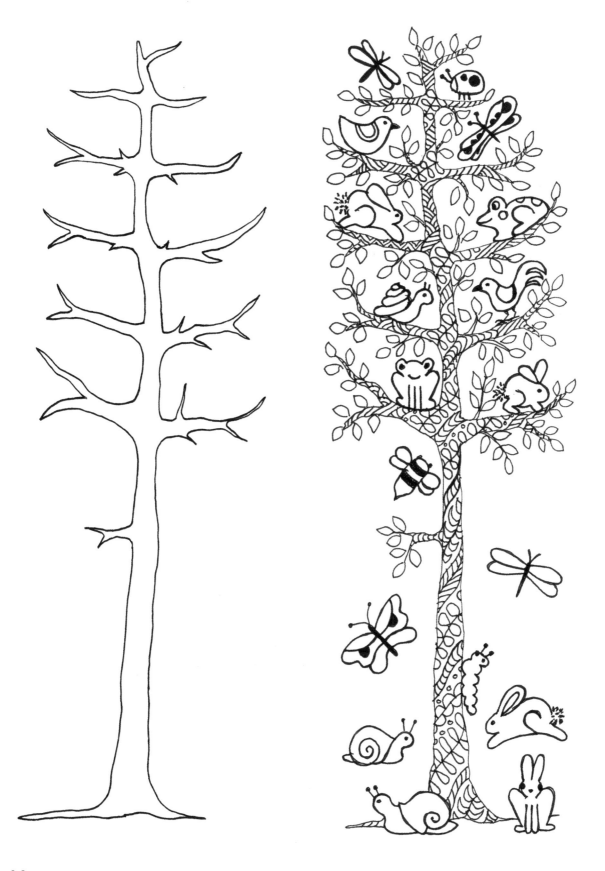

Color It!

First color the black-and-white scene, then use the empty tree as the start of a whole new piece of populated art.

Project: Decorated Gourd

Turn a plain gourd into a beautiful, nature-inspired work of art. The hard part is getting your hands on all the materials, but once you have them, you'll be astonished at how easy this project really is. Two sources for gourds are *www.WelburnGourdFarm.com* and *www.WuertzFarm.com*.

Materials

- Clean gourd or gourd bowl
- Black spray paint
- Graphic #1 black pen by Sakura (with pigment ink) or other similar pen
- White gesso or white acrylic craft paint
- Paintbrush
- Clear, glossy spray paint

1 **Paint the inside.** Spray the inside of the gourd with black spray paint first so that any paint that escapes the interior can be painted over later. Be sure you are spraying where there is plenty of ventilation. Allow the paint to dry.

2 **Paint the gourd.** Use a brush to paint the surface of the gourd white to create a background for your design, and allow the paint to dry. You may need to apply 3 to 4 coats for smooth coverage. Alternatively, leave the gourd unpainted for a natural look.

3 **Draw the design.** Brainstorm and prepare your design, keeping in mind the shape of the gourd. Draw your design with a black pen on the gourd. Use the pen to outline around the design, leaving a narrow white edge. Fill the background with black.

4 **Finish the gourd.** Use a jar to lift the gourd off the work surface. Lightly spray the outside of the gourd with clear, glossy spray paint. It is important to apply many thin coats so the glossy finish will not drip. Let each coat dry. Turn and tilt the gourd as you spray each coat until you have a beautiful glossy surface.

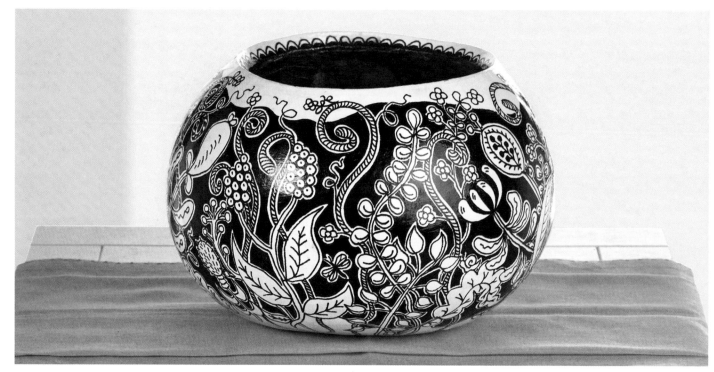

Project: Paper Art Doll

This delicate and beautiful doll makes a great decoration in a window, sheltered garden, kitchen… really, wherever you want to place her. Working with the beads takes a bit of patience, but the finished effect is lovely.

Materials

- White and black cardstock
- Black .05 MICRON pen or other similar pen
- Color markers, such as Tombow markers
- All-purpose glue
- Sharp pointed awl
- 18-gauge wire
- Beading needle
- Beading thread
- E-beads

1 **Cut the shapes.** Cut a doll shape from white cardstock. Cut two doll shapes that are ⅛" (0.3cm) larger than the white doll shape from black cardstock.

2 **Draw the designs.** Draw FloraBunda designs on the white doll with a black pen. Color the designs with markers.

3 **Add beads.** Use an awl to punch tiny holes around the head. Using a beading needle and beading thread, add beads all around the head, and then tie off the thread.

4 **Assemble the doll.** Glue the two black doll shapes to the back of the white doll shape and allow the piece to dry. Punch a hole in each hand for the hanger. To make the hanger, string beads on wire and attach one end to each hand.

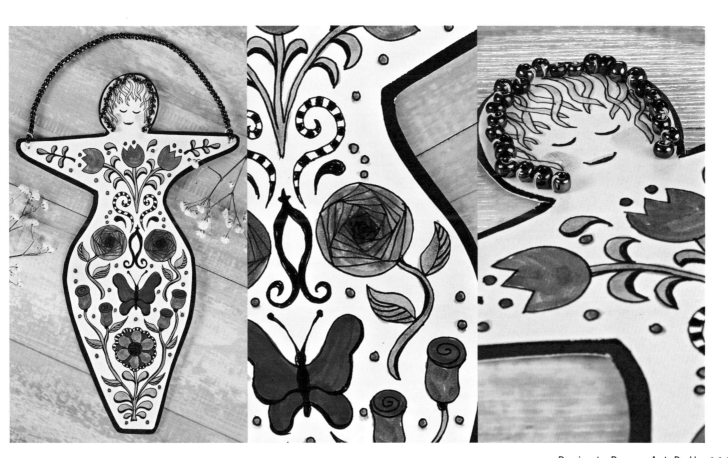

Letters and Alphabets

You can use FloraBunda designs to decorate both standalone letters and entire alphabets.

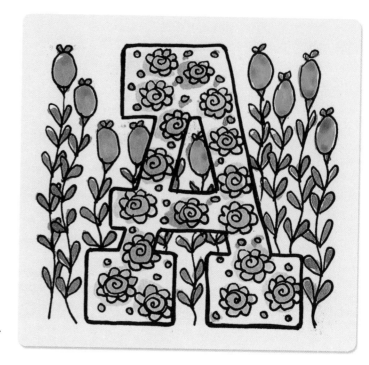

Simple Monogram

Follow the simple step-by-step monogram on this page to make a quick embellishment that adds a pop of color.

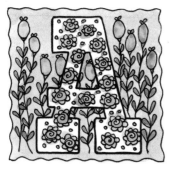 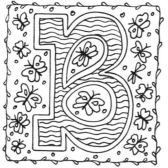 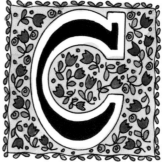

You can take many approaches to a monogram. Fill the letter itself with designs, or just fill the background; add color to the letter, or the background, or not at all. So many possibilities!

 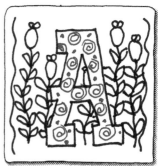

1. Draw the letter and add an outline.

2. Add design elements in the background.

3. You can leave the monogram as is, or…

4. …you can add designs inside the letter itself.

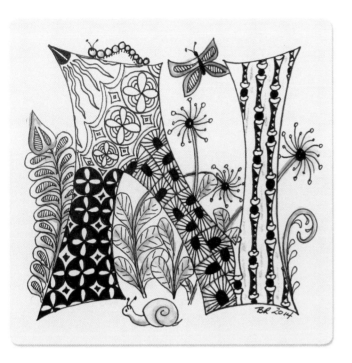

Elaborate Monogram

Everyone likes to see their initial, especially when it is emblazoned with hand-wrought embellishments. Elegant letters can be awesome art with versatile gift-giving possibilities. This densely detailed monogram uses Zentangle tangles and FloraBunda design elements for embellishment.

BY BARB ROUND, CZT, BARBROUNDCZT.WEEBLY.COM

 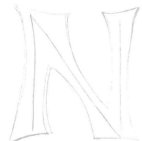 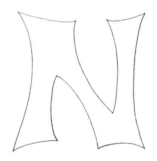 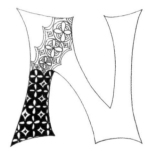

1. Draw a basic letter with a pencil.

2. Draw an outline to create a blocky letter.

3. Trace the outline with a pen and erase the basic letter pencil lines.

4. Start to draw tangles in the letter.

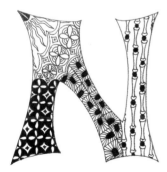 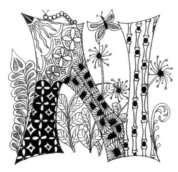

5. Fill the entire letter with tangles.

6. Draw FloraBunda designs in the background of the letter.

Brush Marker Alphabets

These alphabets are done in brush markers and decorated with a variety of little flowers, buds, and leaves. Enjoy making these sweeping strokes that you can achieve with brush markers.

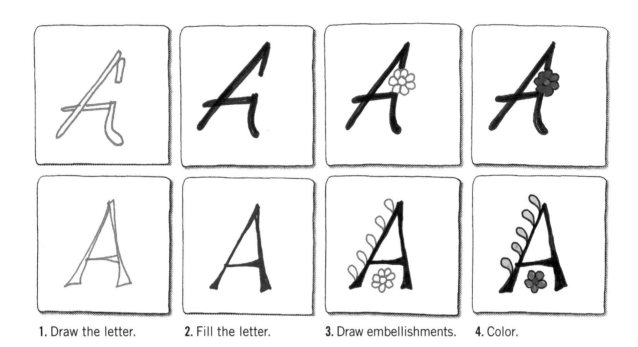

1. Draw the letter.　　**2.** Fill the letter.　　**3.** Draw embellishments.　　**4.** Color.

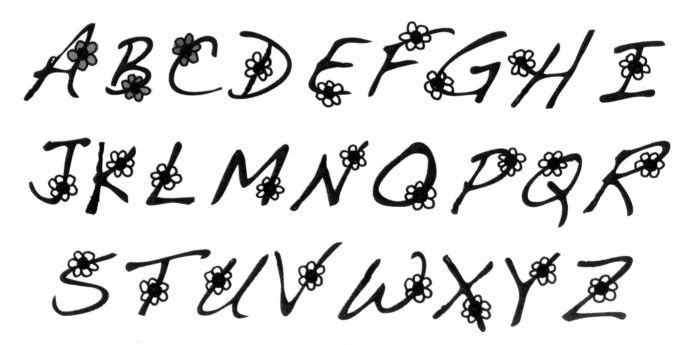

Font used: Handwriting Dakota

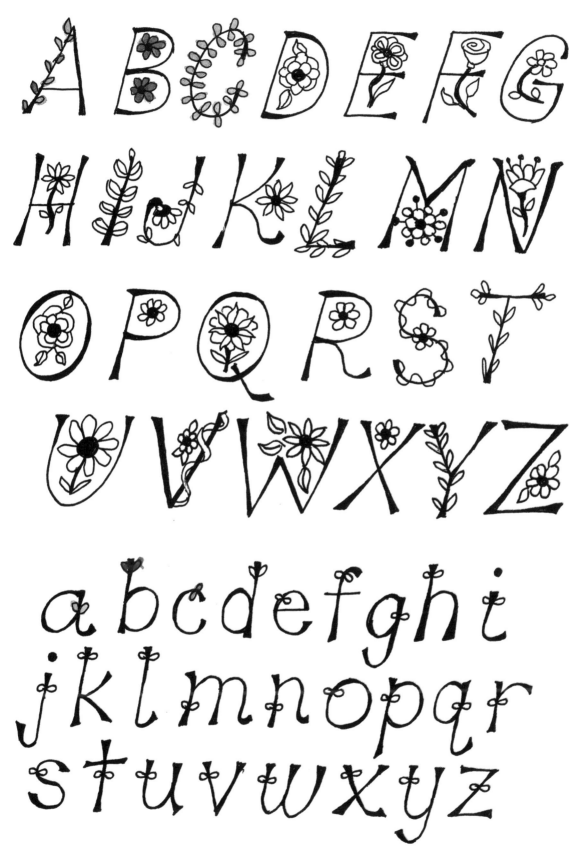

Hand-lettered alphabet

Watercolor Alphabets

With outlined alphabets like these, you can really fill letter space with color. Whether you choose to make every letter the same color or mix it up, the effect can be stunning.

 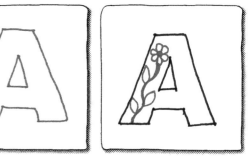

Draw the outline of a skinny letter, and then add a design in its background.

Draw the outline of a fat letter, and then add a design inside the letter itself.

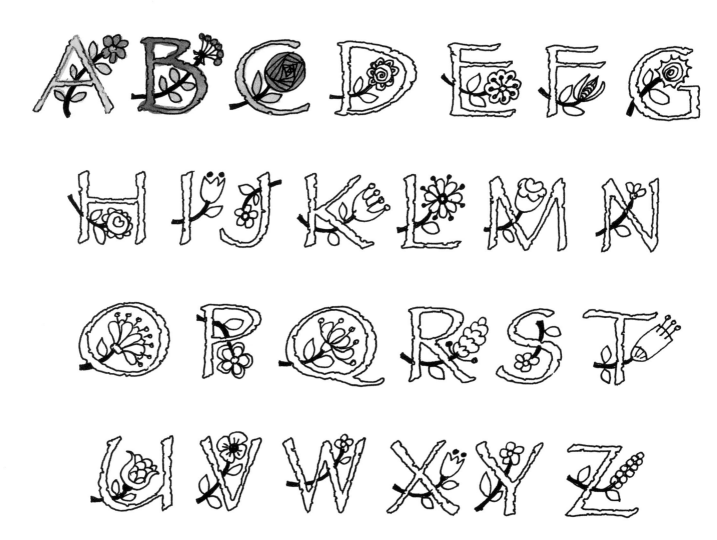

Font used: Papyrus (Outline)

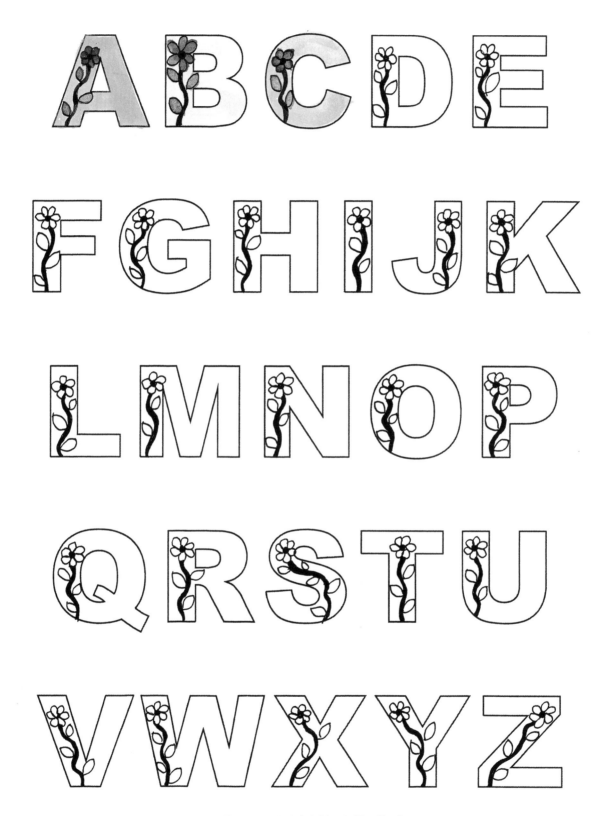

Font used: Arial Black (Outline)

Design Index

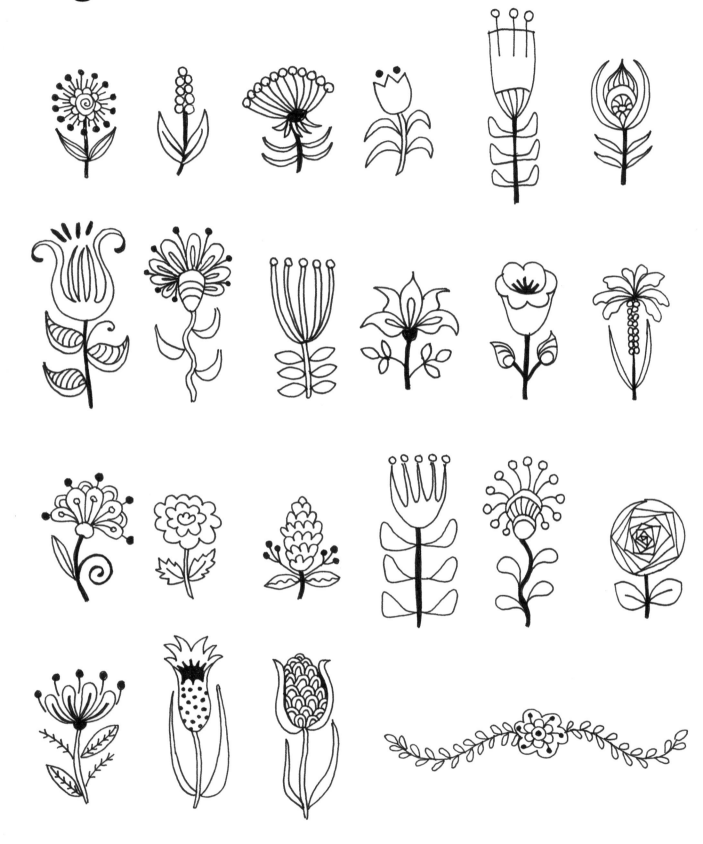

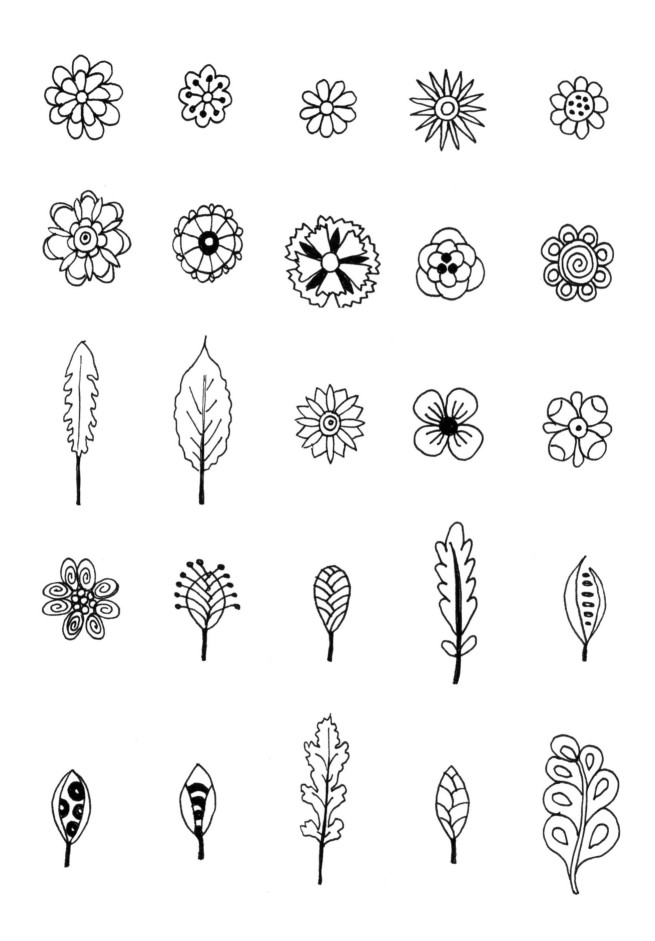

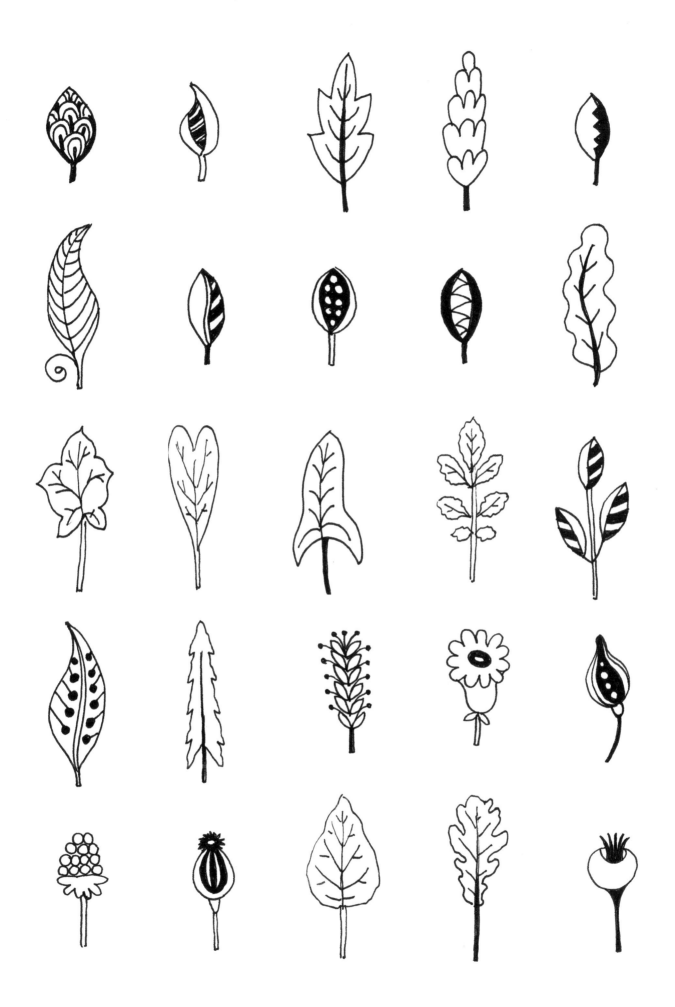

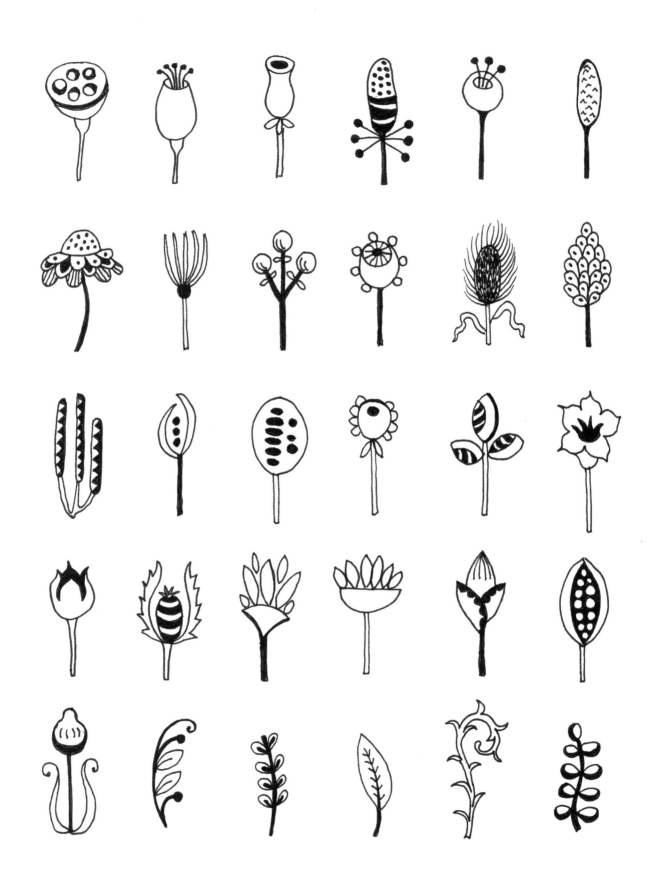

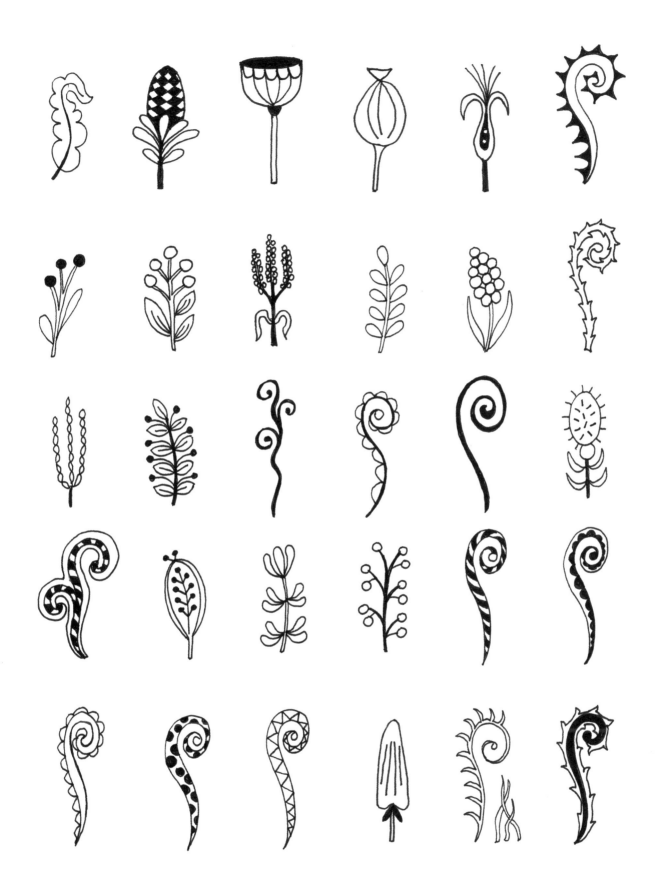

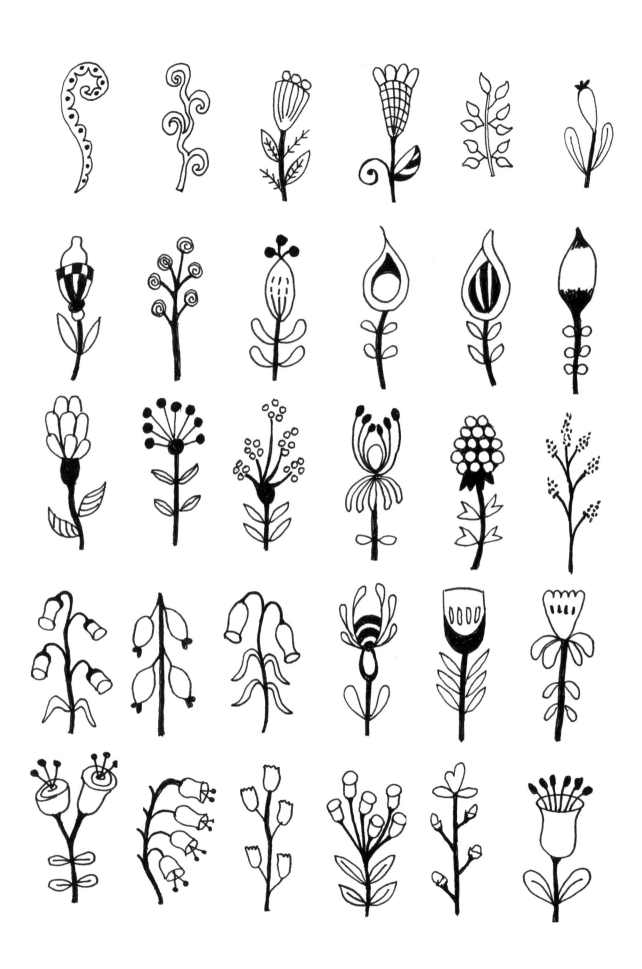

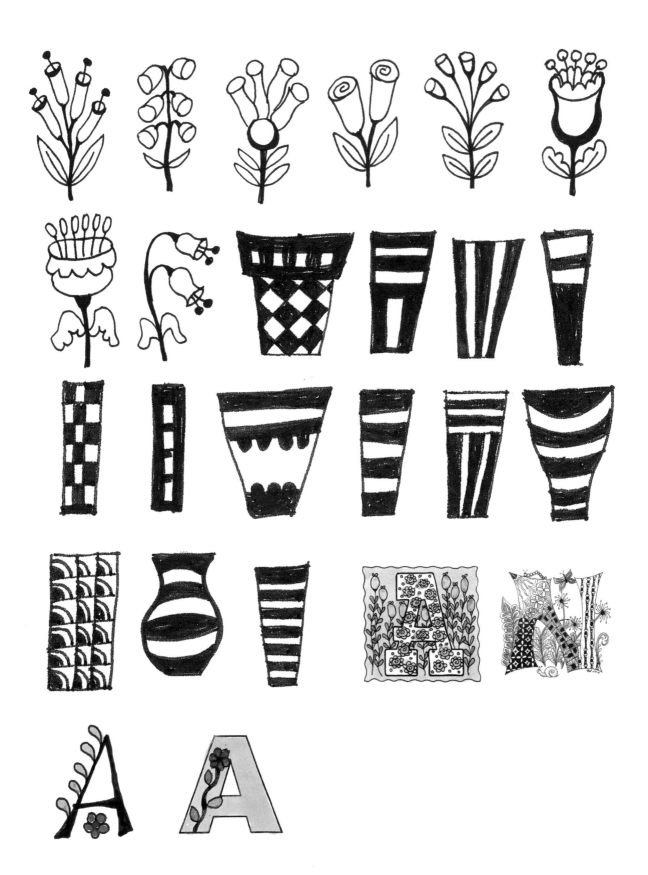

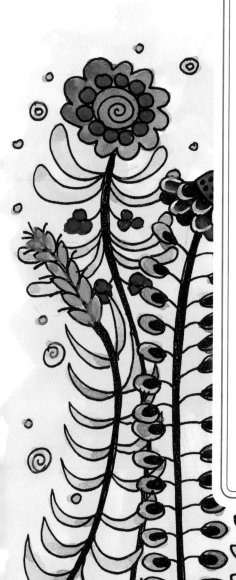

Friends are the Bouquet of Life

A Little Bird Told Me...

Bloom and be free

Embrace life and bloom

Grow where you are planted

Love grows in a garden

Beauty in nature

THE EARTH LAUGHS IN FLOWERS

Bloom and be beautiful

Happiness blooms from within

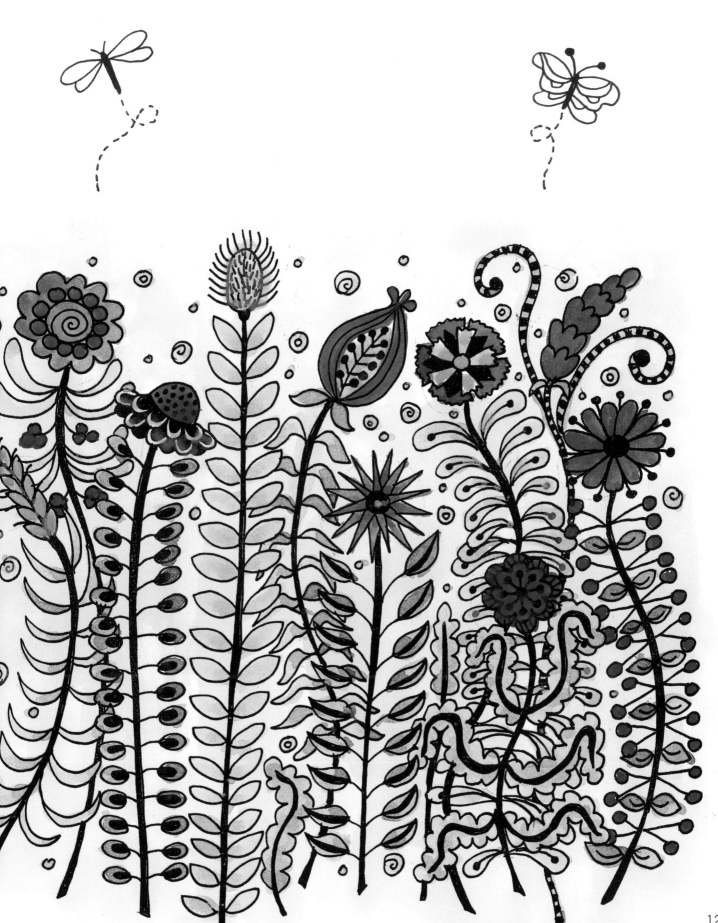

Index

Note: Page numbers in *italics* indicate projects.

About the Author

Suzanne McNeill, CZT, is the author of more than 30 best-selling books, including *Joy of Zentangle, The Beauty of Zentangle, Zentangle Basics* through *Zentangle 12*, and *Zen Mandalas*. She is a designer, author, columnist, TV personality, art instructor, author, and lover of everything hands-on. Her Zentangle-inspired paintings have been called "mesmerizing art." Suzanne founded Design Originals (an imprint of Fox Chapel Publishing), the leading publisher of Zentangle® books. She was voted "Designer of the Year" and received the "Lifetime Achievement Award" from the Craft & Hobby Association.

You can contact Suzanne at *suzannebmcneill@hotmail.com* or visit her online at *www.SparksStudioArt.com* and on Facebook at *www.facebook.com/sparksstudioart*. She also shares her techniques and ideas in free YouTube demos and at *blog.suzannemcneill.com*.